THE BABY'S CROSS

BY

C. GALE PERKINS

To: Kirstin
Hope you enjoy!
many Blessings
Gale Perkins
C. Gale Perkins

ISBN: 1-4107-9369-9 (e-book)
ISBN: 1-4107-9368-0 (Paperback)
ISBN: 1-4107-9367-2 (Dust Jacket)

Library of Congress Control Number: 2003096730

This book is printed on acid free paper.

Printed in the United States of America
Bloomington, IN

1stBooks – rev. 09/26/03

ACKNOWLEDGEMENTS

To my husband Evan, who inspired me to write my life story. I know he will be smiling down on me when my book is published.

To God and the blessed mother for giving me a strong faith that has brought me through many crosses in my life and made my burdens lighter.

To my mom, who left this world at age twenty four. Thank you for the gift of your poem. The title of my book is in your honor.

To my children, Alan, Cindy and Paul, you are the special angels in my life. I love you with all my heart and soul.

To my grandchildren, you are the gifts of your parents to me. I love you all so much.

To my friends who, thanks to God, are many. Your gift of friendship overflows in my heart.

To the clowns in my life who were there when times were lonely and life stood still: Hap, Cheerful Charlie, Daisy June, Great Aunt Tillie. Thanks so much. A heartwarming thanks to my favorite clown and partner Hayseed #2, my grandson Jeff, you are the best.

To Mike, my nephew and the son of Aunty Eunice, a big thanks for taking an interest and helping me get this book up and running.

Thanks to my friend and favorite photographer Catherine B. Thompson, for the color photo's that appear in my book. Thanks Buff.

To Erv Harmon, my new life partner whose patience and love have kept me inspired and excited at times when I wanted to give up. He was the best critic in his ever so gentle way. Thanks Erv.

DEDICATION

This book is dedicated to my late husband Evan F. Perkins, who was my best friend. He was a great dad, grandfather and friend. Evan was an inspiration to all who met him. He is the true love of my life. Thanks Evan.

CONTENTS

AUTHOR'S NOTE

My husband Evan died on September 6, 1996. I have been reflecting on our forty-two years of married life and how this wonderful man helped me to learn about life and all that I had missed in my childhood. He is gone. Hot tears rolling down my cheeks, my heart beating so fast it felt as though it was going to explode.

I heard a voice calling to me, "Mom it is time to leave now. The limousine is here." It took me a minute to realize it was my daughter speaking to me. It was time to leave for the funeral. My body stiffened.

I looked at my daughter. Her eyes were filled with grief and pain, trying to be so strong for me, and I said, "Cindy, I am not going." Getting in that car and leaving would make everything so final.

Having faced so many traumas in my life, this had to be the most difficult for me. Cindy gently convinced me that we had to go. Looking at her and my two sons, Alan and Paul, gave me the courage and strength to get in the car for the longest ride of my life.

To think of a future at this time seemed impossible. I felt empty and hopeless. I had to drift back to how Evan had taught me to cope with difficult times and really call on all the skills I had learned. I found comfort in holding a doll that I created from childhood, but then it reminded me of all the things that had been taken away from me in life such as my parents, my childhood, my health, but none as painful as losing the love of my life.

It was time to start looking back on my journey in life and reflect on all the positive happenings, to write the story that Evan thought was so important to share with the world. My story is one that tells of pain, hope, love, faith, and determination to live.

My life started on November 14, 1933. It was during a period of time when so many families were hit with an epidemic of tuberculosis. My premature birth was the cause for much worry, and many things were tried to save my life. My story begins on my date of birth at which time I was given the name of Cynthia Mitchell.

BIRTH TO THREE YEARS OF AGE

On November 14, 1933 I came into this world two months premature and weighing in at just a little less than two pounds. In those days they didn't have the technology of today to keep babies alive, and I was sent home to die. My journey towards survival began when I left Boston City Hospital in Massachusetts shortly after birth and went to my grandparent's home in Dorchester, Massachusetts.

My parents were Marjorie Leona (Logan) Mitchell and Joseph Archibald Mitchell. My mom was living with my grandparents at the time as she and my dad had separated. My grandparents, Mary Francis Crowley (Logan) and McGrady Lang Logan, along with my Mom did everything they knew how to keep me alive. They tried different formulas as my Mom was unable to breastfeed, yet I continued to reject whatever they put together. I was losing weight fast. They would keep me warm by setting me in a box close to the wood stove and wrapping me in many blankets. My mom did not know what to do and was losing hope. One day she was sitting with me wrapped in a blanket, rocking me and singing to me when a knock came

1

on the door. The neighbor from down the street had recently given birth and was blessed with an abundance of breast milk. She had heard that I was not thriving and was rejecting all formula. She told my mom that she was blessed with an abundance of breast milk and wanted to share it with them for me. My mom and grandparents were willing to try anything at this point. They carefully put some milk in a bottle and began feeding me. An hour later I was sleeping and had not rejected the breast milk. What a wonderful and exciting day for the home on Cedar Street. I had no problem keeping the milk down. I slept for two hours and woke up, and they fed me some more.

My grandmother walked up the street and reported the good news to Mrs. Coakley, who then gave her more milk and told her that she could have as much as she needed. My grandmother Molly sat at the kitchen table with my mom, and they tearfully yet joyfully thanked God for this miracle. I continued to flourish and gain weight much to the delight of not only my family but the whole neighborhood. When it was time for my christening, my mom asked Mrs. Coakley's son John to be my godfather; Aunty Eunice was to be my godmother.

When I was six months old my mom and dad were divorced. My grandmother and grandfather talked about adopting me. My grandfather received a small pension from the government due to an injury in the war; his children also received a pension until they were twenty one. He felt it would be helpful to my mom if they adopted me; this would allow me to receive the same monies and it would also help my mom. The adoption took place when I was 2 years old. My grandparents became my parents, my aunts became my sisters, and my uncle Paul became my brother. My mom was in the status of a sister but was still my mom. The big change was my name. I was now Cynthia Gale Logan but was called Gale, except by the Ford family whose son Donald called me Baby Gale because the families were always telling him to be nice to Baby Gale. It always tickeled me later in years when the song *I'm my own Grandpa* was written; I could relate to it.

The household I lived in was filled with love. I became the focus of everyone. My survival was a miracle and to this very religious, Catholic family it surely was a gift from God. Ginnie, the youngest daughter of Molly and Mac was twelve and would spend a lot of time with me,

helping her mom and my mom Marjie take care of me. She told me later in life how she would take me to the park and comb and brush my beautiful, black curly hair and dress me in all the beautiful dresses that had been bought for me and also made by my great-grandmother in Chicago who owned her own millinery shop. Ginnie told me later on in years that to her I was like a live doll.

Mollie spoiled me and would tell everyone in the house that whatever the baby wanted she should have. I really loved tomatoes, and when she would buy them at the store and bring them home, she would tie a towel around my neck, put me up on a chair by the sink, and let me eat as many as I wanted. I still love tomatoes; they are one of my favorite foods.

I did not like going to sleep at night. I kept getting up and calling out for whoever would come up and pick me up out of the crib. They would then bring me downstairs, and I would be taken in the car, and they would ride around the block until I fell asleep; then they would bring me back and put me in my crib. I had really captured the heart of this household and at a young age knew how to get them to respond to me.

Molly owned a lot of rental properties and did most of her renting from the house. Ginnie would go with her and bring me along to collect the rents. Sometimes Molly would go by herself and Ginnie would be left to take care of me. One day when she was caring for me, I was wearing a pair of her high heeled shoes. I started to go down the cellar stairs with her, then tripped and fell. Ginnie immediately picked me up and tried to get me to stop crying. I eventually did but not until she read me several books and gave me as much candy as I wanted. I was two years old at this time and Ginnie never told anyone about my fall as I appeared to be okay.

The year 1935 brought many changes to the home on Cedar Street. My grandfather (Mac) was to die. A lot of sadness filled the house; Ginnie was depressed and was not singing and dancing like she did when her dad was alive. She spent a lot of time just sitting around. My grandmother (Molly) was a strong woman, and although she missed Mac very much, she continued to run the household and tend to her rental business. She depended more on Ginnie for help in collecting the rent and doing other errands for her. I was always able to go with Ginnie when she was collecting the

rent, which I enjoyed. My mom began to date a man named Ernest Wilson; she married him and in 1935, and they had their daughter Elaine, who is my half sister. They moved out into their own place.

One day when Ginnie was babysitting me, she bought me a new book. I loved the book so much that I would ask Ginnie to read it to me over and over. The book was titled *A Child's Garden of Verses*, and to this day it is still one of my favorites. Excited about the book, I went downstairs to show it to my grandmother. When I went to the dining room, she was on the floor. I sat beside her and showed her the book, but she wasn't talking to me. I called her name several times, then called to Ginnie and she came down and reached for a ring of keys that was lying on the dining room table and placed them on the back of my grandmother's neck. Molly would sometimes suffer from high blood pressure and pass out; pressing the cold keys against the back of her neck would usually revive her. Eunice came home in the meantime and realized that my grandmother was not breathing. I just remember a whole lot of excitement and crying going on in the house. The next thing I remember is my grandmother lying in a tall bed of satin,

surrounded by lots of flowers. Many people were coming in and out of the house, everyone sad and crying. Then my grandmother was gone. Aunty Catherine took over managing the household, and caring for Ginnie and me.

The year before my grandmother died, she had taken in a boarder who was a good friend of the family. He was a very frail and sickly man who appeared to have a very bad cold. My grandmother would make chicken soup for him. He stayed with the family for a short time and then left. Shortly after her arrival, Aunty Catherine realized that everyone seemed to be pale and had a cough. She called a doctor and it was suggested that we all had been infected by the new and most dreaded disease, called consumption or tuberculosis. As a result, we were all scattered around. My mom (who had a new baby) and Eunice were sent to Rutland State Sanatorium in Rutland, Massachusetts. The baby Elaine was sent to her grandmother's; Ginnie and I were sent to North Reading State Sanatorium in North Reading, Massachusetts. My uncle Paul went to Boston City Hospital. Aunty Catherine was left with the task of cleaning out the house and getting rid of everything or trying to sell it. This was a task that was difficult as not

many wanted anything to do with anything that they felt was contaminated. I was kept in observation in North Reading for one month. While they found no signs of tuberculosis in my lungs, they did discover that I had a bone standing out in the middle of my back and by x-raying my back saw that it was diseased. Tuberculosis struck not only the lungs, where it was highly contagious, but also struck many other parts of the body, particularly bones, eyes, ears, glands, kidneys. It was only contagious when in the lungs so we could all be in together and not isolated.

Again I had to say goodbye to a loved one. I had grown much attached to Ginnie, and for me to have to say goodbye even at three was very hard. I cried until I had nothing left in me and fell asleep on the ride from Reading to Lakeville where I would spend the next twelve years of my life.

ADMITTED TO LAKEVILLE STATE SANATORIUM

On October 5, 1936 I was taken from North Reading and brought to Lakeville State Sanatorium. I was crying, kicking and begging, not wanting to leave Ginnie at North Reading State Sanatorium. After arriving at Lakeville I was put in a ward with nine other children under the age of six. My first experience was being brought to a building where I was put on a cold table, where they told me they were going to take my picture. After many pictures they moved me into another room that had a terrible smell to it. I was placed on a table that supported my head, buttocks and feet, and dressed in a body stocking. They told me I would feel a warm, wet feeling as they were going to put me in a plaster cast that would keep my body nice and straight. Once they started with the plaster, I knew why the room smelled so badly. When they started to put on layers of plaster around my body, they suggested that I pop my tummy up as far as I could to give me some extra room inside the cast. They put an iron bar about two inches above my knees, then plastered around that to keep my legs separated. Then they cut the stocking casing and turned it up around the edges of the

9

cast, and when it was all done they said I looked beautiful. When the plaster was dry, the picked me up by the top of the cast under my neck and the bar between my legs, placed me on the gurney and brought me to the children's ward. They put me in a pair of denim bloomers over the cast and a white Johnny (a hospital gown that tied at the neck and back) and then put the apron strap around me and tied me in the crib.

The daily routine of the babies' ward was breakfast each morning at seven thirty. This was brought to us on metal trays; we had a cover to lay down on the sheet first so the tray would not leave marks. After breakfast they would bring a basin of water for us to wash our face, and we would brush our teeth and have our hair combed. There were two hair styles; the staff decided how our hair was to be combed. Some had a Dutch clip, while the rest had a braid on one side. At nine in the morning they would move us out on a long cement porch with open sides. The open portion was for the girls from ages six to fifteen who were in the big girls ward; the roofed portion was for the younger children. Around ten in the morning they would bring us tomato juice and water, and then at eleven we would go

back in the ward and wait for lunch. We could have a book to read or a doll to play with during this time. After lunch we would be moved out onto the porch from one to three. This was time for us to take a nap. Each of us had the cloth cover that we put down under our metal trays when we ate and would fold them and put them over our eyes to keep the light out to make it easier for us to fall asleep. I really didn't like this part of the routine, as I was always curious and wanted to know what was going on every minute. At three we would have tomato juice and water and our cribs would be moved back inside the ward. We would play and talk and wait for supper which was at five. From five to six, we were prepared for the night routine. Faces washed and teeth brushed, we settled in for the night. Some of the children would cry a lot before they went to sleep. The ages ranged from six months to six years. They would be crying for their moms and dads. For me the nights were the hardest.

FEAR OF THE DARK

The night was frightening to me—the darkness would start to settle in, then the stillness. The children sobbed, calling for their mothers. The nurse would come in and say, "Silence, everyone!" Her shadow was clear on the dark brown floor in the moonlight; my heart would beat faster from the fear. All of a sudden I would hear a squeaking sound as the big green gate that led to the porch was opened. My crib faced a set of double French doors the staff used to bring the cribs onto the porch in the daytime. At night, I would see witches coming through the gate. They would be laughing, talking and shaking their fingers at me. I would take the sheet and blanket and wrap it around my head and cover my eyes so I wouldn't have to see them. They would sit in the corner by the doors and laugh and talk and I would scream! This would bring the nurse on duty to the ward as by now all the children would be awake and screaming. The nurse would come to my crib, pull the blankets off my head, and ask what the problem was; when I would tell her about the witches she would say that it was my imagination and tell me to go back to sleep. This

happened over and over again; one night the nurse came in and pulled the blankets off of my bed completely. She said I could not have them back until I stopped screaming and waking everyone up. It was hard to lie in the crib without the blankets; the fear would swell up in my heart. I held my hand over my mouth so the nurse could not hear my sobs. My tiny body was trembling inside the heavy plaster cast that encased it. Tears would flow silently down my cheeks onto the sheets until finally I would fall to sleep from exhaustion.

Waking in the morning, I would find myself not only soaked from tears but also from urine. The coldness during the night without the blankets would cause me to wet the bed. This always meant that I would be punished. Punishment consisted of being isolated. No one could talk to me; I could not play with any of my toys; a screen would be placed around my bed so I could not see the rest of the children. When the medical director made rounds with the charge nurse, they would tell me what a bad girl I was for creating a disturbance and that as long as I continued to do it, I would be punished. When night came I was again without covers. I was told that there would not be a sheet

and blanket for me until I learned to stop screaming and upsetting all the other children. At four years old that was a pretty hard thing to do. I was able to hold back the fears and the screaming for a few nights, then fear would return and I would be repeating all the same things again. When I tried to figure out who the witches were, I realized that they looked like some of the doctors and nurses. In fact, they looked a lot like the ones that I was fearful of in the daylight. My biggest fear was they would open the doors and come in and get me.

I tried to hear what they were talking about. I was afraid to look directly at them in case they saw me. I would hear them talking about surgery for my friends Angie and Rosemary, who had already moved to the big girls' ward. Also, they talked of the girls who were going home. Oh, the longing in my heart that it would be me. I never heard them mention my name.

THE BABY'S CROSS

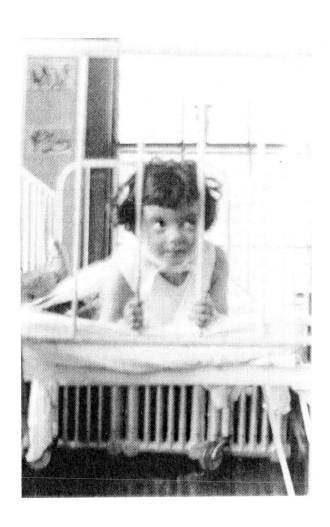

I look out of my bed through big brown eyes framed by my pitch black hair. My tiny body is encased in a plaster cast from my neck to my knees as I lie on my stomach,

perched on my elbows. This is the view of the world that I will experience for the next twelve years.

Did I say bed? It was a metal crib with bars on all sides. I was tied in this crib with an apron strap, which had four ties on each side tied to the side bars of the crib and two ties that tied around my neck and then to the front bars of the crib. I could not get out if I wanted to, only four years old, unable to run and play. The look on my face was one of determination, telling the world that I could tackle anything that was to come.

You could see in my large brown eyes the questions that were deep in my heart. How did I get here? What happened to me? Why was I unable to run and play like other children? Why isn't my mother here? I really need her here with me. The plaster cast was so heavy; my elbows chafed from rubbing against the sheets.

I would have a visitor each month; a tall thin lady, she was my aunty Eunice, my mother's sister. I asked her where my mother was and she said, "She is very sick." Aunty Eunice said that she would visit my mother following her visits with me and would tell her all about me. She told me I had Mom's big brown eyes and her

16

sweet singing voice. She was like a messenger who would bring good news back and forth. I asked her if she would bring Mom someday when she got better. She promised she would. She would give me a big hug and when she would leave I would cry. I missed her when she left. She was so nice and smelled so good and would make me laugh, but most of all it was her hugs. I couldn't feel them too much on top of the plaster but I knew they would feel good.

The answer to all the questions that were in my mind were somewhat answered in the poem which is the title of my book, "The Baby's Cross," written by my mom. The poem was written after one of the visits to me and then to my mom from Aunty Eunice, who had brought the message to her along with the picture.

THE BABY'S CROSS

Her big brown eyes twinkle roguishly.

(As they use to when she'd chase her cat.)

Oh dear, why did I think of that?

She asked for him today and wondered,

"Did her Saunders miss her while she was away?"

The kitten died but she never knew

The sorrows of childhood should be so few.

Yet—the cast extends from her sturdy shoulders to her knees

And, when one thinks of these, and many other things,

How joyously she laughs, how sweet she sings.

Then when her little story of her wants are done,

She whispers, earnestly, "Some day I will run and run.

So far that nobody can catch me again.

With a sigh, your heavy heart whispers back—
AMEN

By Marjorie Logan Wilson to Gale 11/16/36
In memory of Eunice's visit to my darling Gale

THE UPSIDE DOWN DOLL

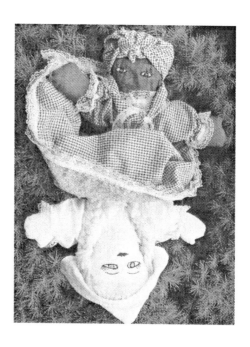

In the spring of 1937, I was visited by a beautiful lady with black hair and brown eyes. She had a pretty pink dress on and smelled so nice. I don't remember seeing her before. She told me she was my mother; I couldn't seem to remember her. I had already been in the hospital for less than a year and was visited by Eunice but never by this lady who called herself my mom. She said, "I have a surprise for you." She handed me a bag and inside of it was a very soft doll. The doll looked like Aunt Jemima, a character in

one of my storybooks. She had a red and white checked scarf tied on her head and a red and white checked dress with a shawl tied around her shoulders. She was the same color as my friend Marianne, and I told my mom I was going to name the doll after my friend. I hugged the doll and thanked my mom for bringing her to me. She said that I should turn the doll upside down and see what happened. I did this and on the other end was another doll; she was a Dutch girl with blonde braids and a blue print dress with pink flowers. She was wearing a white Dutch hat that looked very similar to one of the nurse's hats, except that the nurse had a black stripe on hers. I reached up and gave my mom a big hug and kiss, and when I let go I noticed a tear roll down her cheek. This made me sad. When it was time for her to leave, she said goodbye and told me to be a good girl and do what the nurses told me to do. She also told me to make sure I said hello to God every day. I wondered who God was, yet promised to say hello to God to make my mother happy. Then she turned to leave; I started crying but not loudly as I didn't want her to hear me. She looked back and waved. I remember feeling what I know today is loneliness. I hugged the doll she brought, not

21

knowing that I would never see my mother again. I clutched the doll close to my cast and held her tightly in my hands. This doll was the biggest comfort to me through the next several years. When I finally left the hospital, my aunty Catherine would not let me bring my toys. She said I had to leave them as they might have germs in them. I said, "Well, I have to bring my upside down Marianne doll with me," and she said, "No," My heart was heavy. I did not want to leave this doll behind as she was my comfort and knew all my secrets, fears, hopes and dreams. All my pleading and begging did me no good. The doll was left behind.

Later in life my husband and I would search antique shops looking for an upside down doll. I would describe the doll to the shop owners, and although they would know what I was talking about I continued to hear the same answer over and over again: "Sorry, we don't have one." I would ask if they knew of any vendors that did. The answer was always the same—no. After many years of searching, my husband suggested that I should make one; he thought it would be very therapeutic for me. I agreed to try it. A friend had given me a book on making upside down dolls a

few years previously and I had made one for my granddaughter. I was off to the fabric shop the next day, picked up all the material for the doll and came home and started on her. It took me about four days to create her. I had to embroider her face (or faces) on and try to remember what they both looked like. I found myself going through a lot of emotions, feeling angry that she had been left behind and lonely for my mother and, at the same time, excited to be creating my lost doll. When she was finished she was so beautiful and I felt so satisfied. I held the doll and hugged her for a very long time. Memories flashed in my mind of the day the beautiful lady came to visit me and brought me the doll. It was her last visit to me and the last time I was to see her as she died at age twenty four.

MOVING TO THE BIG GIRLS' WARD

Right up until age six, things continued the same in the baby ward. I lost my fear of the people who sat out at night. They still did, but I learned just not to look or listen to them. Finally, on November 14, 1939, I reached the age of six and was told I would be moved to the big girls' ward. This was a real exciting day for me. I made sure my upside down doll Marianne came with me. They packed all the other dolls and toys I had and wheeled me out on a stretcher to my new bed in the ward. The bed was made of white iron like the crib, but it did not have any sides on it. However, I was still tied in with the apron strap. The bed had a canvas bag tied to the footboard which had lots of pockets, and I could keep some of my special things like coloring books and crayons in it. I even found a pocket in it big enough for my upside down doll. The room looked so enormous to me; it had a very high ceiling and two rows of windows across one side of the room, one atop the other, with an expanse of wall in between. It was pretty nice as you could see the sky, the sun, and the moon and stars at night. You could also watch the birds in the trees and see

airplanes as they flew by. The room was so big and spacious compared to the little baby ward. There were seventeen other beds in the ward; nine on each side with a square oak table in between each bed, where we could put some of our things. This was a very exciting move for me; there were more friends to talk and play with and because I had few or no visitors, the other children's visitors would come and talk with me. My friend Angie was right next to me and my new friend Phyllis was a couple of beds down.

The next thing that happened was I was taken out of the cast and put into a walking cast that ran from my shoulders to just above my thighs. This was wonderful as I could now walk around and visit the other children. I could go outside on the porch and play games like red light, giant steps, and all the other childhood games anyone could think up. My very favorite thing to do on the porch was to run up and down when it just became dark and have the moon chase me back and forth. I would run until I was exhausted and it would be time to go inside for supper. I didn't have to eat in bed once I was up and walking around; I would eat at a table with the other children who were up and around. Somehow the food just tasted better when you didn't have

to lie in bed and eat. One of my favorite dinners was one we would have on Sunday. It was mashed potatoes, steak, and peas and would always have watermelon rind pickles with it. We would have my favorite desert (ice cream), and then after dinner the nurse in charge would pass out a piece or two of candy. We were able to stay up until seven thirty at night and then we could go into the bathroom and wash our face and brush our teeth and get ready for bed. Sometimes the attendant on duty would tell us a story if she wasn't too busy. It wasn't as dark in the big girls' ward as the light from the nurse's office and the kitchen shined in the big room. When the weather was good we would be taken for walks in the morning for about an hour and then again in the afternoon. These were so special. I loved the spring time as we were able to pick violets and lily of the valley. One of my favorite things to do was to go into the space of the big magnolia tree and just sit on the lower branch and watch the other children play. It was cozy and smelled nice there. I would get tired on the walks so this would be a nice place for me to rest. I didn't want to let the attendant know I was tired because I was afraid they wouldn't let me go on any more walks. We had to walk

two by two, always holding the hand of one of the other kids. I would take turns; one day I would walk with Angie and the next with Phyllis. One day as we walked I saw some flocks and asked if I could pick some (as long as they were wild flowers we were allowed to pick them). I was told yes. As I picked the flowers I kept feeling a stinging on my hand, and I would just rub it and then both hands began to sting. When I looked I saw bees on my hands. I had got into a bees' nest. I started screaming, and they hurried me back to the ward and gave me some medicine. I swelled up and itched so bad inside the cast that they started pouring calamine lotion down the cast until they could get the doctor to come and cut it off. I slept the rest of the day because the medicine they gave me for the itching made me very sleepy. I was fine the next day, but I never picked flocks again.

In the summertime if we were up and walking around we could go to the weenie roasts they had once a month and cook our own hot dogs. They were so delicious. We even toasted marshmallows. They allowed the boys from the boys' ward to come also. It was a new freedom for me and I loved every minute of it. Now, when we went out on the

porch for our morning time and our rest time in the afternoon, my bed would be out from under the roof. I was able to see everything as I was out in the open.

After the visit from the lady who brought me the upside down doll, I looked forward to the time between one and three in the afternoon when they would move our beds out on the porch and we had what was called rest hour. We had to cover our eyes with a cloth to keep the light out and hopefully we would sleep. I always would set the cloth so I could peak out around it and see what was going on. I liked watching the smoke billowing out of the large chimney stack that was off in the distance. I asked one day what it was for and they told me it was the generator that kept all the power going at the hospital. I found the smoke to be very comforting. Sometimes it would be white and fluffy like the clouds and other times it would be gray and dark. The days it was white and fluffy I would dream I was floating away, far away from the hospital, never having to come back.

To my surprise one day as I watched the white smoke billowing out of the chimney stack, I saw a form of a beautiful woman in a long white dress with black hair and a

smile like an angel. She waved to me and gave me a big smile. I felt a peace come over me that was almost unexplainable. She told me loud and clear that she would always be with me, and I could see her anytime I looked into the smoke. I realized that the face I was looking at was the same face on the lady who came to visit me and brought me my special upside down doll. I wanted to talk to her and thank her for this doll that I loved so much, but as soon as I tried to reach her she would again disappear. I would beg, "Please come back here. I want to touch you. I want to talk to you." She would float and smile until she got to the top of the cloud of smoke that appeared to go right into the blue sky. I knew she was going into heaven. I loved going out onto the porch and would try at other times to see her in the cloud of smoke. It was only at the time between two and three in the afternoon that she would make her appearance. Some days I would feel so lonely and cry when she would go into the sky with the smoke. I wanted so much to tell her all the things I was doing and to smell her perfume again and feel her kiss on my cheek. I can't remember how long I saw her in that cloud of smoke. Time was not a big factor when you're six years old and laying in bed unable to

run and play. I only knew that she was very special and I loved her.

I was to find out many years later that the time I started to see her was after she had died, not too long after she brought me the doll. She was my mother, this Angel that I was seeing in the smoke. I still stop and pause and look at a chimney stack when I go by one. When the smoke is billowing out of the stack I look to see if maybe, just maybe I might get a glimpse of this angel who I know in my heart was my mother. Hopefully I will see her again in her flowing dress just floating around in the billowing smoke. The ache of wanting to touch, see, and smell the perfume and feel the kiss has never gone away. I still feel that empty lonely feeling in my heart on a warm summer day when the clouds are fluffy and I see a chimney stack towering in the sky. It takes me back to the days of trying to catch this beautiful person that I felt so connected to and wanted to talk to. Will the hurt ever go away?

I did not have many visitors on the big girls' ward as Aunty Eunice had to go into the hospital again. The nurses saw me crying one day and asked why. I told them that I was very lonely when all the other children had someone

visiting them and I didn't. I would feel very sad. They pointed out some of the other children who were without visitors and asked me if I would like to spend time with them. This made me feel special. I also was asked to spend time with the children who would cry when their visitors would leave. I could always make them laugh. I really loved to make funny faces and they would just laugh so hard (they would call me the hospital clown) and say, "Make another funny face." I would spend a lot of time out on the porch in the good weather looking way down the road through the glass partitions to see if I had any visitors coming. I longed for my own visitors. No matter how upset I became, I always felt better when I ran up and down the porch, even though tears would be rolling down my face, I found it to be a relief for me to just run and run.

When September of 1940 came around I was old enough to start school. This was to be a very exciting day for me. There were only three of us in the first grade. They would roll our beds out on the porch in the good weather and group us together, and we would anxiously wait for our teacher to come. There were three teachers who came and taught at the hospital. I was hoping I would get the one

who to me was so beautiful she had blond hair and would wear real pretty dresses. When the day came in September, sure enough this beautiful lady was to be my teacher. Her name was Mrs. Jay, and she told us all we were going to learn the first year of school. The dress she wore that day was one I liked very much. It was red with big white polka dots. It reminded me of the dress that Minnie Mouse wore. She had bright red lipstick on and big white earrings and a necklace. She smelled like the lily of the valley flowers that I would pick in the spring. She wore lots of pinks and blues and dresses with big flowers. I really looked up to and admired her. I was anxious to get started. The first thing we learned was the alphabet and printing our names. I was still in the body cast so I had to learn to write flat on my back. This was done by holding a heavy piece of cardboard with one hand, the paper would go next, and then I would write. My arms were straight up in the air as I would write. At times they got pretty tired but Mrs. Jay would let me rest. We then started to learn the vowel sounds. They were on manila cards that she would hold up, and we all had a chance to sound them out. I was just getting to really be able to put the vowels with the consonants when my school

was interrupted. It was time for me to have my first surgery on my back. The doctors explained to me that after the surgery the bone that was sticking out in my back would be nice and flat.

THE FIRST SURGERY

The day before the surgery took place the nurse who was second in- charge named Miss Currie and who I really liked came with a tray that had all sorts of things wrapped up on it. Bottles of what looked like soap, one with a clear solution, adhesive tape, and several other things. My heart started to pound as I had no idea what was going to be happening to me.

She explained that she was going to shave my back and my left leg and make it all nice and sterile for my surgery. She started pouring the soap in the dish. She called it green soap. She then washed my back with it and begin to shave whatever hair might be on my back. The razor felt really strange. She wiped my back with the clear liquid called alcohol, which was very cold. She opened up a small enclosed bundle of cloth and wrapped it all around my back to my stomach. She did the same thing with my leg. They were to remove a bone from my leg and graft it into my spine to replace the part of the bone in my spine that was diseased. She told me that they would be doing the surgery at eight in the morning, and I should eat a good

supper as I would not be able to eat any breakfast in the morning. After supper the nurse came with a large metal container with long red rubber tubing at the end and said I had to have an enema. This certainly was a very unpleasant procedure; I started to vomit and felt as though my stomach was going to burst. I was glad when this was over.

When the lights went off around eight that evening I began to get that fear that I would have when the witches would appear to me in the babies' ward. What is going to happen to me tomorrow? Will it hurt? Will I be sick? I decided that vomiting was not my favorite thing to do. I finally fell asleep feeling all alone. The morning came and I was taken into the room that they put me in when I misbehaved and again they cleaned my back and leg with the soap and wrapped the areas up. They took one of the tray covers that we laid on our beds to put the metal trays on and wrapped my head up in it like a turban. Then I was put on a stretcher and was taken over to the surgery building. The kids were all saying good bye to me. My new friends Angie and Phyllis said, "Bye. I love you, Gale. See you soon." Would I see them again? It sure felt very scary to me, like whatever was happening was not good.

The surgeon was a doctor from the big Boston hospital called Massachusetts General Hospital; he looked at me with a big smile and said, "Hello, Gale. I am Dr. Van Garden," as he patted me on the head. "We are going to fix you up and you will be just fine." They moved me to a very cold table, strapped me down, and told me to count to ten. As I counted, a round rubber cone was placed over my nose and mouth. It smelled just awful! I tried to hold onto the table because I felt as if I was about to float off of it. The next thing I knew I woke up in a small room over in the women's ward, all alone. A nurse I had never seen before came in and told me I had just come back from my operation and that I might feel a little sick. She showed me the kidney-shaped metal basin just as my stomach got queasy. My mouth felt like cotton; within seconds I started to be sick and this went on for two days. I was very thirsty but was afraid to drink anything because I would just be sick again. They brought me cracked ice; I would suck on it and somehow I got through the third day. I was not in the cast but in a shell that went from my neck down to my toes. When I was on my back they would take the top half off. When they moved me on my stomach they would strap the

top on and turn me over. I was up on what was called horses; they look like saw horses only smaller. This kept me up in the air and they could just slide the bedpan underneath it. On the third day I was able to eat. I was fearful of being sick so I ate very slowly, and when I found out that I was going to be okay, it made me very happy. I didn't like the feeling of the top of the shell cast being put on and they would turn me over. I was always so afraid that I would fall. The one good thing about it was when they turned me on my stomach and took off the back shell I would get a back rub wherever the bandage wasn't and I liked that. I could also just place a book on the bed and read it easier than holding my arms up in the air. The wooden horses that lifted me up off the bed gave space for a book to be placed directly on the bed. I couldn't read much but looked at the pictures. I was in the private room for two weeks. One day I heard the nurses say it was time to remove the sutures in my back and leg. Again the anxiety built up. They arrived in the room with a metal tray with metal instruments and took off the wrappings on my leg and started to take out the stitches. This was not a very pleasant feeling. The nurse felt by telling me how many there were and counting as

each one was removed it would make me feel better. It just raised the anticipation of the next one to come, and my heart was just pounding. My mouth became dry and I thought for sure I would be sick. I cried and asked for some water, but I had to wait until they were finished. I lay as still as I could with my eyes closed until it was all over. I never felt pain after the surgery, but having the stitches out was frightening and very painful, not something I would forget in a hurry. They told me I had to wait a couple of days to make sure there was no infection, then I would go and have the body cast put back on from my neck to my knees and would stay this way for the next six months. I was very happy when this day came as it was the same day I was to go back to the girls' ward and be with all my friends again. Most of all I would be able to go to school again. I was so excited to start school again and to see my friends. I didn't like having to stay in bed; I missed going out into the porch and running with the moon. Soon another birthday came; it was now 1940.

SPIRITUALITY ENTERS MY LIFE

Turning seven in November of 1940 marked the beginning of my spiritual teachings. These teachings began when I was told that I was Catholic. I would start going to Catechism lessons and learn prayers in preparation for my first Holy Communion.

When the day to start the lessons finally came, it was exciting and scary at the same time. It would be a mixed group, consisting of myself and several boys who were also Catholic and would be studying the catechism with me.

This would be the first time that I would be with boys, and I found myself to be feeling very shy. The lessons were held in the boys' locker room. I was wheeled in on a stretcher. Looking around I discovered that out of six of us I was the only girl in the class. When I would speak my voice came out like a whisper and the boys would laugh. My face would get all flushed. When I would try to speak again my voice would squeak and more laughter would prevail. It took me about four lessons for me to settle in and be comfortable. I would count the days until the next lesson. I was learning something very interesting

that would shape my life forever. I was being taught about God the Father, a very special person to me who would always be there even if I couldn't see Him. I had a feeling of peacefulness fill my heart to find out that I could talk to someone and ask for help in the form of what was called prayers.

This was the best thing that I had been taught; I really liked this Catholic teaching. What a wonderful gift. "He is our Father," the priest said. "You can talk to Him anytime and He will be there for you. You cannot see Him; He is up in heaven."

"Where is heaven?" I asked.

"In the sky." was the priest's reply.

"Is there a Mother?" I asked.

"Yes, there is; she is Mary, the Mother of Jesus and she answers prayers also. When you make your first communion you will be given some special beads to use to pray to Mary."

My mind was spinning; my imagination was running all over the place, and I certainly had a good one. I immediately had parents. God can be my dad and Mary my mom. I had read about ghosts and spirits so in my childlike

mind that is what they were to me as I couldn't see them but knew they were there. We use to put a sheet over us and pretend we were ghosts; the vision I had of God and Mary was of them looking like that. Imagine parents that never left you, never having to say goodbye. I could not wait to get back to the ward to tell this to the other children. To tell them that when their parents left they didn't have to feel bad and cry because my new parents never left; they lived in the sky and I would share them with everyone.

The priest also said that God was everywhere so I knew for sure that he never left me. I didn't have to feel sad anymore when the other children had visitors. I had my own visitors; it wasn't long before I was feeling so comfortable with my new parents. I would find myself talking to them for long lengths of time and telling them all my hopes and dreams and asking for little favors, not only for myself but for the other children.

The most wonderful part of having parents like God and the Blessed Mother Mary was they never got upset with me, and I was fast learning about the power of prayer. It really worked. The other children would ask me to talk to my special parents and ask them for things that they

wanted. Unknowingly, I was forming my own little prayer groups and asking for things like helping someone to get up and walk or have someone come to visit them; to their surprise these requests were answered. I was so excited when a prayer was answered that I found myself wanting to pray more and more.

Later in life I related to this Bible verse: "The child grew and became strong in the spirit" (Luke 1:80). I made my first communion in May of 1940. My aunty Catherine arrived with a beautiful white dress that she had made for me and a white headpiece with a veil that was so pretty. Looking in the mirror I thought I looked like Mary, but aunty Eunice told me I looked like an angel. I stopped and thought for a moment and realized that I must look like the lady in the smoke. This thought made me feel warm all over and for a moment I could smell her perfume.

Just as the priest had said, they brought me some special beads called rosary beads and they were teaching me how to say them after the communion service. The beads were red like rubies and they had a red velvet pouch to keep them in. I could keep them tucked under the mattress of my bed so I could take them out and pray with

them anytime I wanted to. I felt so different that day as I walked up to receive the communion. It didn't taste very good, and I was trying hard to keep it from hitting my teeth (we were told not to let that happen). It stuck on the roof of my mouth and I wanted a drink of water so bad. The feeling of never having to be alone again swept over me like a big warm blanket; I felt so cared for and loved. The communion took place outside on the front lawn of the hospital; there were flowers all around and the smell of violets and lily of the valley in the air was just beautiful. I felt so very special. My parents were looking down at me. I knew they were happy because I had learned my prayers and had been very good while waiting for this special day to come. This was the day that would shape my life of spirituality for always. This was a day of love, hope, peace, and a strong faith forever. I still have the strong faith I had that special day. I felt the love of my family and my spiritual family and the universe all around me that day. The sun was shining, there were some fluffy clouds in the sky, and there was the smell of flowers and the green grass. How could I have wanted more? It somehow felt like what I pictured Heaven to be like were God and Mary live. They

were to be my loving companions for the rest of my life, and I feel their presence as I write this story.

A LOOK INTO THE ROUTINE OF DAILY LIVING AT LAKEVILLE

Our days on the big girls' ward would start around six in the morning. They would come and take our temperature and pulse to make sure no one was sick. Then, we would all get bedpans or if we were up and walking we would go to the bathroom. Then, they would pass out wash basins and give us our toothbrushes and toothpaste. The toothbrushes were carried in a canvas bag with our names on each pocket.

At seven they would come around with the breakfast trays. There were three of us at the time that could be up and around. I was one of the three. They had a bench type table with legs that could be picked up and folded against the wall. The three of us would be served our meals at this bench. It needed to be balanced just right so the legs would not fold under. I was always the one who sat in the middle because I was the smallest. One of the kids that sat with us was always starting trouble. The rules at mealtime were that you ate without talking and didn't look at the person next to you. Just eat as quickly as possible. The time

allowance was a half hour, and then the trays would be collected. The mealtimes for me were hard as I was very sociable and found it difficult not to join someone who was talking and having a good time. I would start to giggle, laugh and respond, and the next thing I knew the attendant would tell all three of us to drop our spoon or fork, and then she would take the first girl and bang our heads together and the second girl and the third girl and bang our heads together. Yes, I was the middle girl and my head would get banged on both sides. I tended to be somewhat of a rebel and I would start laughing after they banged my head, and the attendant would push my face in my plate of food. Did we learn our lesson? Well, maybe for that day. The next day we would start all over again. I would just brace myself and take it over and over again. Eventually we would have more than three of us that were up and around and we would go and eat at the big table. Somehow with more of us they were not paying as much attention to the talking or giggling.

After breakfast we would have to go to the bathroom and relieve ourselves or sit till we did. Then, it would be getting our hair combed, receiving our medicine and our

vitamins, and getting set for the head nurse Miss Dickey to come and make her rounds. If we were up, we would stand in front of our beds with our hands folded. For the children in bed, they would lie on their backs with their hands folded and wait for Miss Dickey to come to them. She would come to each one of us and say good morning, calling us by our names, and we would answer back, "Good morning, Miss Dickey."

"And how are you today?"

And we would answer, "Fine. Thank you, Miss Dickey." When she would go to the next bed after mine I would stick out my tongue and the kids would start to laugh; sometimes she let it go, but other times she didn't and I would get punished.

If you were up, you went back to bed to get ready to be moved out onto the porch for sunshine and fresh air. Each bed was moved out by the orderlies, placed side by side in rows, some of us in full sun and others would have the heads of the beds in the shade under the roof if there was room as the babies would be in the shade. In the summer we would have what was called sun treatment. It would start in May; we would be put in full sun for five

minutes lying on our backs in the morning. In the afternoon, we would lie on our stomachs for five minutes. This would go on for a week. The time was increased weekly until we reach the capacity of the two hours we would be out on the porch. At the end of the summer season, we were all very nicely tanned. Visitors from organizations would come for tours of the hospital and I would remember listening to them saying, "They are all so nice and brown." When they passed by my bed they would pat my head and say, "Your hair is so black it has a blue color to it" and "You're as brown as a little berry." I really got tired of being patted on the head; I had the desire to stick my tongue out like I did to Miss Dickey, but I knew I would get caught and then punished.

 We would be grouped by grades and the teachers came from nine to eleven. During the summer, the attendant who was called Mrs. Tommy would come and stay with us for the two hours we were out in the sunshine and fresh air. She would teach us all the latest songs. At ten a.m. we would have a cup of tomato juice and water. At eleven the beds would be moved back inside for dinner. Our big meal was at noon time. At one in the afternoon we

were moved back out on the porch for rest hour, which was from one to three. At three we would again have tomato juice and water, move back inside, wash our face and hands, and be free to play until supper time. At seven thirty we would get ready for sleep, wash our face and brush our teeth. Depending on who was on duty, we would say our prayers all together.

At eight sharp the lights went out. I would always take my special red rosary beads out and say them, some nights falling asleep before I would finish. They would then turn on the big wooden box in the office (the radio). We would listen to *The Life of Riley*, *Fibber Magee and Molly*, and *The Lone Ranger*. I am sure there were other shows. I just remember the above ones. In the summer they had cookouts, walks, bubble blowing, picking wild flowers, and many other activities. In the winter on Tuesday afternoons we went to the movies. This was one of my favorite things to do. We also went to Occupational Therapy, or she would come to us. This routine was the same for all the years I was at Lakeville. The break in the routine would be during birthdays and the holidays.

BIRTHDAYS AND HOLIDAYS

When my birthday would come around in November, my aunty Catherine and my uncle Dan would arrive with a great big birthday cake for both wards, the girls and boys. They would bring gifts for everyone also. Each year it would be something different. Uncle Dan would make several trips back and forth to the car to bring in the gifts. At first, being the little kid that I was, I would ask Uncle Dan if the gifts were all mine and he would say, "No they are not young lady. They are for all the children." Uncle Dan and Aunty Catherine did not have any children of their own and loved bringing these gifts to the children.

The year that Mickey Mouse was born, Uncle Dan brought Mickey Mouse watches for all the children. He would always make me wait to open my present last after all the others had opened theirs. I didn't mind the wait as I knew I would have an extra gift besides the ones he brought to the other children. This year, when I was opening my gift I was so excited as I knew I to would get a Mickey watch, but much to my disappointment when I opened up my gift, it was not a Mickey watch, but a Snow White

50

watch. Uncle Dan and Aunty Catherine waited in anticipation for my joy. I ended up with big tears falling down my cheeks, and I sobbed and sobbed as I so wanted to have what all the other kids had. Uncle Dan started to get a little cross with me. He said, "Young lady, what is wrong with you?" I said that I wanted a Mickey watch and I handed him the Snow White one to take back. He explained that he would not take it back as it was his special gift to me. The reason he chose it was he said I looked like Snow White, and he wanted me to have this special watch.

When Uncle Dan and Aunty Catherine left, I called the nurse and asked her to please put the watch in my special locked box in the nurse's office. She said I might change my mind and want it later, but I never asked nor did I ever see the watch again. My aunt and uncle did the same for all the rest of the birthdays I had in the hospital. They never bought me the same gifts as the others, but I was never disappointed again. The cakes were always as exciting as the gifts. They were so big and they would bring one over to the boys' ward and the other would be on the girls' ward. They were so beautiful when all the candles were lit. I could hear the boys singing happy birthday to me

from their ward. Thanksgiving was not as festive, but we would have turkey and all the trimmings.

Christmas was my favorite. They would bring in a great big tree and put it right in the middle of the ward. I loved the spot they chose, as my bed was right in the middle on one side. The ward was about fifty feet long with beds lined up on each side. They would have to cut a lot of the branches so they wouldn't be to close to our beds. I have no idea how tall the tree was, but it would almost hit the ceiling. The first thing they would do was put the star on top and then they would put all the lights on. We would all hold our breath waiting to see if the lights would all light up. They put the garland on next and then the ornaments and last but not least the icicles. They were the only decoration we could help with. They would let us throw them from our beds if we couldn't get up as long as our bed was near the tree and as I mentioned, mine was. We would laugh when we missed and got it in the nurse's hair or on her shoulder. She would laugh also. The nurses and attendants seemed to be happier around the Christmas holiday. When the tree was finished, all of us who could write would send letters to Santa. The ones who couldn't

write were helped by those of us that could. About two weeks before Christmas the gifts would start coming in the mail. They would take them and put them under the tree and tell us we could not touch them. There were packages in all shapes and sizes. We would peek to see who they were for and most of them would be mine. My aunts, uncles, and other relatives would send me many packages. I would spend the rest of the days till Christmas trying to guess what was in the packages. Some of my relatives would come before Christmas and bring pretty wrapped packages, and they would put them under the tree. The tree would get so full they would have to put some of our gifts in a special room until Christmas.

There was always a special program at Christmas and some of us would be chosen to participate. This one year I was so excited to be one of the chosen ones. I was to be part of a group that held out cards spelling Merry Christmas. My part was the R's for the room where we hung up the clothes, R for red ribbons and bows. The teacher was so impressed with how I would get out there and belt out my verse that she asked if I would like to have a poem all of my own to read, and I was so delighted. I just

loved being on stage in front of an audience. I had the poem memorized in two days I wanted so much to please Mrs. Jay. When the day came for the program, I was dressed in a long, white dress with red ribbons hanging from smocking in the front of it and I proudly went out to say my poem:

A Possibility

I said please for the past two weeks
Washed and combed my hair.
Ran errands for other folks
Not even a minute to spare.
It's awfully hard before Christmas
Can I remember everything?
Guess if it was any longer
That I'd be sprouting wings.

I loved the last part of the poem as I would put my hands on my shoulders like wings, and everyone in the auditorium was applauding. It was a great moment for me;

I could see the smile of approval on my teacher's face and that made me happy. I really felt very special that night.

Christmas Eve had approached, and it was time to hang up our stockings on the metal hook our beds. We all wrote our own notes to Santa and put them in our stockings. We would sing all the Christmas songs we had been taught and some Christmas carols, and then we would really try hard to go to sleep.

The next morning the cotton socks would be replaced with a red mesh stocking filled with all kinds of candy. The cotton sock would be on the table between our beds and would have a tangerine and some nuts in it and a small toy or favor of some kind. We went through the morning routine and then would wait patiently for Santa to arrive. He would arrive every year at exactly ten in the morning with a big brown bag filled with toys. I was fascinated that Santa knew all of our names. It was several years before I realized that the nurse was telling him before he would get to our bed. Only one year did Santa miss coming to the ward, and that was the year we all had the chicken pox. He came up the ramp and left all the gifts in the kitchen and waved as he left. We always got at least two of the gifts that

we would put on our list. After Santa left, the staff would start to pass out the presents under the tree. There was always a big box for me from Miami, Florida from Aunty Catherine and Uncle Dan. I was so excited that I got a present from so far away.

Then, Christmas afternoon would come and the visit from my stepfather and his family would start. Ernest Wilson would come with arms full of presents and his two sisters Edith and Ella and his brother Everard, their arms filled with presents. I would always receive the latest of children's books from Edith. This year it was my favorite story, *Black Beauty*. I had a wonderful library of books thanks to her. Ella would bring me feminine things like nail polish, jewelry, and nice perfume and powder.

Ernie, my stepfather, would bring me the latest dolls. I had many Shirley Temple dolls, but this year was the best. Ernie brought me Snow White and the Seven Dwarfs. They were at least two feet tall. They looked so real. I know that what I liked mostly about company coming besides the presents were the hugs and kisses I would get. They always felt so good. Even though I couldn't feel the hugs under the plaster cast, I just knew they were something special. What

was the hardest was when they left, but then I always had my special parents God and Mary. To this day, I still love Christmas and birthdays.

ANGIE A SPECIAL FRIEND

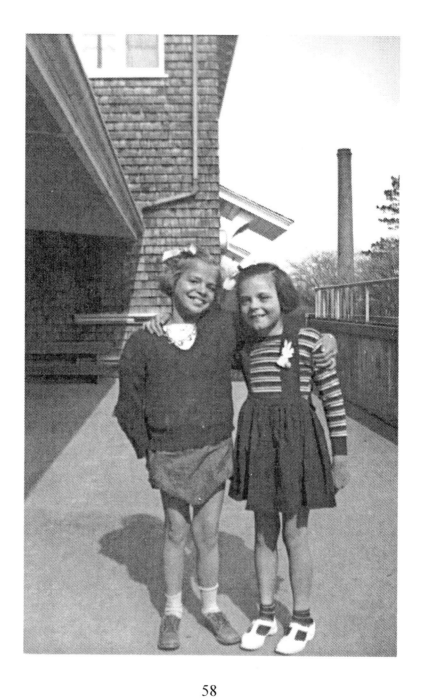

Angie was the girl in the bed next to mine. She was nine years old and I was six. She had light brown hair and brown eyes and a beautiful smile. When we first met, we instantly became friends. When her dad and brother would come to visit her, they would always bring something for me. Angie's sister Pauline was in the same hospital as Ginnie, North Reading Sanatorium in Massachusetts. We would all write notes to send, and they would bring us notes in return on each visit.

Angie was of Greek ancestry, and I loved it when it would be Greek Easter. The Priest would come and bring red hard boiled eggs and powdered candies that were sort of like a jelly. Angie was a very religious girl; she would read her book of prayers every day in the early morning and evening. She would also tell me that she said prayers for me, to help me stop getting in trouble. One day as I was being punished in solitary for sassing back to a nurse, I heard the staff in the kitchen talking about Angie's sister Pauline, who had died but the father didn't want her to know. He would continue to bring letters from Pauline to Angie each time he would visit. They said he felt she had

enough in her life to deal with and she needn't know this pain. I never told this to Angie what I had heard that day.

Angie took good care of any gift that her dad, brother or her brother's girlfriend would bring. She had a collection of pretty pins that she would pin on the bed bag that we had at the foot of our beds. She had counted one day and had at least sixty of them. I would ask my aunty Catherine to bring her a pin each time she would visit me. Angie really liked that. When Aunty Catherine went to Florida, she would send pins that were palm trees and flamingos or anything that represented Florida. It made me feel good I could ask for something special for Angie as her Dad was so good to me. At Christmas I would have the nurse take money from my account and buy a pin for her. Angie was my confidant at night after the lights would go out. We would whisper our hopes and dreams about what we would do when we left the hospital. We definitely were going to live together as we considered ourselves sisters.

One day we had our first fight. It was over a little girl who had come into the hospital named Ellie. She was only six months old and I thought she was mine to look after. One day I saw Angie talking to her and I got very

jealous and told her that she was mine to take care of. I shoved Angie away from the bed, she pulled my thick black hair, and then I pulled her very thin brown hair and to my surprise a hunk of her thin hair came out in my hand. I suddenly felt terrible. The fight stopped immediately, and not knowing what to do I gave her the hunk of hair. She took it and made a little braid and hung it on the metal hook on her bed. She didn't talk to me for a few days. I was so sad. One morning after school I noticed that the hair wasn't on the hook anymore, and Angie told me she forgave me. That was the first and only time we were upset with each other. She started to get very sick; sores were breaking out all over her body. The doctors would talk in low voices to the nurses discussing what they were going to do. Eventually, Angie was running a fever and she was unable to walk. She couldn't keep any food down. I spent all of my time talking to her, rubbing her head, and holding her hand. Then one day she could barely open her eyes. They moved her over to the women's ward in one of those private rooms where I was when I had my surgery. I was given permission to visit her twice a day for a half hour. She looked like an angel lying under the white sheets. I would

come back to the children's (East) ward feeling so lost and sad. I asked the nurse if she was going to die, and she said, "Don't be so silly." I didn't want to see them wheel Angie down to the morgue like we had seen so many others being taken there. The morgue where they took people when they died was under the back porch on the children's ward. I could see it very clearly from my window. Many times we would see the stretcher with the covered body being taken there. Sometimes at night we would watch them as they put the insides of the organs in the jars. We would all be frightened but not enough to make us stop looking.

One morning when it was time to get up and get ready for lunch, the nurses asked if I would like to help pass out bedpans and wash basins. Anything to get up early I thought. I leaned over to get my shoes and socks from the bottom of the table, and when I came up I saw them wheeling a stretcher with a body on it down to the morgue. I knew right away that it was my best friend Angie. I could tell by the shape of her body; she had lain in a bed beside me for many years. No wonder they wanted me to help them, but it was too late. I had already seen what they were trying to keep me from seeing. The tears rolled down my

face, and I felt as though I was going to be sick. I hurried with my shoes and ran to the bathroom and did get very sick. I then stopped crying quickly; this was something that we all learned at the hospital. I started to pass out the bedpans and the wash basins as they planned. My best friend had died and I was really feeling her loss.

Her dad had died but no one told her. Her brother Peter came to tell me the news, but I heard the nurses saying he was unable to do it. He asked Miss Dickey if she would please tell me and also to give me some of Angie's pins that she collected.

The next morning Miss Dickey called me to her office and said she had something to tell me. I blurted out to her that I already knew and that I wish it had been me instead of her. She was my best friend.

Miss Dickey thought for a minute and looked me straight in the eye and said. "It couldn't be you. I am telling you right now Gale that only the good die young." These words would stick with me for the rest of my life. If it was possible for me to know the emotion of hate, I am sure that is what I was feeling towards Miss Dickey at that moment. I wanted at that moment to tell her how much I did not like

her or the way she treated me and some of the others. I did agree with her about Angie being good. She was the best; I could see Angie's face and hear her telling me, "Gale, please be good. They will put you in solitary and you know how lonely and sad that makes me." So I did as Miss Dickey told me to do so many times. I shut my mouth real tight. She would tell me to zip up my mouth. I really tried to be good, but I just seemed to have this voice inside me that got in the way. Being in solitary for me was not as bad because I would spend time saying my rosary, and talking to God and Mary one of my favorite things to do.

Losing Angie was my first experience with death that I remembered. I didn't feel good at all; I missed Angie saying good night and making plans that we would live together when we left the hospital and all the things we were going to do. Most of all I missed our saying goodnight and saying how much we loved each other. We also talked a lot about our plans when we left the hospital. We were going to live together and be friends for the rest of our lives.

MY SPECIAL FRIEND PHYLLIS

Phyllis was a couple of beds down from me, but we would talk back and forth from our beds. When we were both up and around we played together for hours. Phyllis and I both loved the movies, mainly the musicals with Fred Astaire, Ginger Rogers, Rita Hayworth and just any dancing and singing stars there were in those days. We also both loved Heddy Lamar and Tyrone Power. When we would come back to the ward from a musical, we would put on a show for all the children in the ward; we made it a point to learn the songs and some of the dance steps. We would take the chenille bedspreads off our beds and drape them around us like gowns and just dance and sing till either we got tired or the other children got tired of us. After returning from a Tyrone Power and Heddy Lamar movie we would put on a serious show with the love scenes and all. I was always Heddy Lamar with the long gown on and Phyllis would fold the tray cover up and make it look like a necktie and tuck it in the front of her cast. We really knew how to entertain; at least that is what the nurses told us. They would even stop and watch our show sometimes.

Every year at Christmas time one of the children was chosen by a local organization to receive a special gift. It was Phyllis' turn this year. The gift was a metal trunk that opened from side to side; it contained a doll on one side and clothes for every occasion on the other side. There were hangers to hang the dresses and coats and drawers to put the underwear stockings and gloves and mittens and hats in. This was the most beautiful gift we had ever seen, and right away Phyllis invited me to be the first one to play with her new gift. It took us almost two hours just to look at all the beautiful clothes. There were evening gowns, a black velvet cape, long white gloves, and a beautiful rhinestone necklace with a rhinestone crown for her head. I really loved this outfit. The one that was my favorite was a pink polka dotted sheer blouse and skirt with a big picture hat to match. We could make up all kinds of places for her doll to be going, and each time she would have a different name. This doll was magical. The best time for me was when she would let me play with her doll all by myself. What a great friend.

My other special recollection of Phyllis was how she took care of me after I had more surgery. I had a problem

eating; this was something the staff was very concerned about. The attendant on duty, Miss Butter, was determined that I would eat. She would hold my nose and shove the food down my throat; Phyllis would stand a little away from my bed and be watching what was happening. Miss Butter would then walk away and leave me with the rest of the food and Phyllis would come by and take a napkin from the tray and fill it with the eggs and toast and take it to the bathroom and throw it down the toilet. Breakfast seemed to be the hardest for me; the eggs just made me gag and before Miss Butter could come around, Phyllis would come and remove the food for me. She would also plead with me to try and eat something. She would break the toast in little pieces and mix it in with the eggs, and I would eat a couple of bites.

Her mom never visited, but her dad would come as often as he could. He also would bring me something when he visited. Phyllis left one day. She said goodbye and I would not see her again. I thought that she went home but found out many years later when we met again (after sixty two years!) that she didn't go home. She had been sent to the women's ward. She was three years older than me, and

it was necessary for her to leave the children's ward. No one ever said that she was moved to the women's ward. I started to talk about the events of the hospital, but Phyllis was very vague. Her mother had preferred that she didn't mention the hospital experiences so it all had just left her mind. My family was just the opposite. They encouraged me to talk about the experience plus they had taken many pictures, which I am so thankful for today.

Phyllis loved hearing me talk about all the happenings, and she did share that the one thing she remembered was about a little girl who couldn't eat and the nurse would hold her nose and shove the food down her throat and how Phyllis would take the food away. Tears were rolling down her face as she told this and then they were rolling down mine. I asked if she remembered the little girl's name and she said no. I told her that it was me, We instantly hugged and just held each other for awhile. Phyllis remembered me but hadn't recalled that I was the little girl who she had been so kind to when I couldn't eat.

One of the things she did remember about me is that I always tried to get the other kids to laugh. She said that it was second nature for me to do that and that I was almost

always able to get them to laugh. Phyllis and I are both widows now; she has three children and has grandchildren. She had named her first child after me and was very proud of that; I was very humbled when she had told me after her daughter was born (we had written to each other over the years but never actually met again until sixty two years after she went to the older girl's ward). Life has given us both a lot of twists and turns but we are amazed at the strength we endured to get through it all.

At age seventy two she still has pitch black hair that really shines; she says she has some white ones, but you have to look hard to find them. Her dimples go so deep and are very noticeable as she is always smiling. We hugged and kissed and just kept looking at each other, and I know my mouth felt like it would crack from smiling so much. I put on the tea kettle and we sit each year now for the past three and reminisce, not only about our hospital days but our days now. She visits her niece Catherine in Florida each winter, and we have made plans to keep in touch and visit when we are in Florida. Catherine said she loves listening to me help Phyllis to remember. I am honored to

have such a wonderful friend. These are the best gifts a person can have in their lifetime.

LEARNING TO BRAID

World War Two had broken out. We wondered, "What happened to the staff?" They had gone to war. How would all of us children be taken care of with so few nurses? How would we get our faces washed and our hair combed? We had so many questions running around in our little heads.

Most of the children, including myself, were excited about all that was going on in the hospital. The orderlies were painting the rows of windows next to the ceiling with black paint. They would use the paint can to form a black ring around the lights in the ceiling and then paint the outside of the lights black. This was in preparation for the blackouts and air raids.

One day the staff was discussing how they would get our needs taken care of since they were really short staffed. I heard my name mentioned. Excitement filled my heart; they were going to ask me to help with the combing and brushing of the children's hair. It was mentioned I was quick to learn so I would be the one to ask to do the job.

71

Not quite ten years old, with the cast (called a walking cast) still on I approached my new task with so much enthusiasm. Feeling like a part of the staff, I tossed the canvas bag over my shoulder. It had the children's combs and brushes in it. Each pocket contained the combs and brushes with each of the children's name on the pocket that contained their brush and comb. Filling a container with water, I proceeded to start my new job. I told the kids they could call me Miss Gale. They thought that was funny, but I really liked the sound of it. After all, it was as if I was on the staff now. I had watched the staff combing and braiding the kids hair many times, but when it came to actually doing it, I realized that it was a quite a chore.

The first little girl had a Dutch clip; doing her hair was really easy. I wet the brush and comb and ran them through her hair and brushed down her bangs and she looked good. The next two had the same haircut and again it was easy. The next one was a different story; she had a braid. Looking around, no staff in sight, I began to undo the elastic. Holding the braid in my hand, I undid it carefully, brushed it out, took some hair, and started making a new braid. What I thought was braiding consisted of putting two

strands of hair together and twisting them and attaching the elastic band on the end of it. Much to my surprise the whole thing twisted back and undid itself. What to do now? Glancing at the next kid with a braid, I went to her bed and carefully started to unwrap her braid and noticed it had three strands, not two, and that the three strands were crossed over each other in a weave. Back to the first braid I started all over again. I crossed the three strands one over the other and completed my first braid. It was a bit lumpy, but it was better than the first one.

When all seventeen heads of hair were taken care of, I looked back and was very satisfied with my accomplishment. I then had to tackle my own hair, which was in one braid. The first day I just took some water on my hands, patted the messed up hair from sleeping the night before and let it go at that. I was allowed to continue to help as much as I wanted to. I would make beds, pass out bedpans, dust and help feed the other children who needed it. I really loved all of this learning.

At that time I thought that when I grew up and left the hospital, I would want to be a person that did people's

hair. Years later I would learn that this person was called a hairdresser or a beautician.

My self-taught skill helped me to braid my daughters' hair, my three granddaughters' hair and their friends' hair. A real honor for me was when my granddaughter Danielle asked me to help braid her horse's tail and mane when she was entering into a horse show.

The task that I learned that day in 1942 was to remind me in later years of a famous quote in John F. Kennedy's inaugural address on January 20, 1961: "Ask not what your country can do for you—ask what you can do for your country." This quote really spoke to my heart. It made think back to the time I learned to braid. I had been braiding for my country.

HOPES OF GOING HOME

There was talk between the doctors and Miss Dickey the charge nurse about my being ready to leave the hospital. This was a bit scary for me to hear. They said I was looking good and walking well with my back brace. I was also eating real well. Eating was a problem for me at times. They decided to call Aunty Catherine to make the arrangements.

The day she came we visited for awhile; I was so excited telling her about the staff saying I was ready to go home. She was very quiet and said she would talk to me after she came back from seeing the doctor. She came back with the doctor, and they asked me to take some steps down the middle of the ward which I did. I really couldn't hear what was being said. The physiotherapist was also watching me walk. The doctor and therapist left, and Aunty Catherine told me I would not be going home. She explained that I was walking with one shoulder lower than the other and they were going to give me some new exercises to try and straighten it out. I guess somewhere in

my heart and head, I was happy not to be leaving. This was my life and the talk of leaving didn't make me feel happy.

That night I prayed that I would be able to get straightened out as I heard the other alternative would be to have the same surgery all over again only taking the bone from my other leg. I did not want this to happen.

The next day the physiotherapist came and explained that they were going to put a piece of adhesive tape on the side of my left leg below the knee and when I walked I was to reach for the tape. This he said would help straighten out my shoulder and my back. I did this exercise for three months. I guess it looked good while I reached for the tape, but when the tape was removed nothing had changed. I was still walking with one shoulder lower than the other.

Plans were made to do a second spinal fusion. To me it meant pain, leaving my friends, being all alone in a private room, and going back into the plaster cast from my neck to my knees. The surgery was again to take place in the month of October, the year I would turn ten.

This time it was a lot more frightening than the first. One of the reasons was that I knew what was going to be happening. On the positive side, I would not be as alone as I

was the first time. I felt a lot better because I now had God and the Blessed Mother with me. They would even be with me in the private room. The priest came and gave me Holy Communion, and I was feeling a little better and not so scared. The procedure for this surgery was similar to the first with one exception.

The doctor had to mark the exact spot where the bone had not healed. In order to do this he had to fill a syringe with a black fluid, and it had a long needle attached to it. To me it looked as if it was a foot long. He told all the children that he had to get this black fluid in just the right place, and if he didn't it would have to be done all over again. He told them that if they were my friends they would keep very quiet and not talk or move as he wanted to hit the right spot the first time. I looked at all the kids, and they had such frightened looks on their faces. A few of them held their hands over their mouths; this is what we would do when we wanted to be real quiet and have it appear to the nurses that we were sleeping.

The doctor came to my bed, and the nurses held my hands so I wouldn't try to reach for the doctor's hands. The thought of the needle being put in hurt more than the actual

happening. You could hear a pin drop in the ward. It was all over and the doctor said, "Gale, thank all your friends for being so quiet." I did and I thanked my father in heaven that it was over. The nurse finished putting the sterile dressing on and the same procedure of shaving my back and leg took place. The next morning I was wheeled over to the surgery building; the smell of the ether was as devastating as the last time, and the sickness that followed when I woke up was the same. In two weeks after the stitches were removed I was put back in a body cast and moved back to my place in the big girls' ward.

I started back to school and everything seemed to go along well until one day it was noticed that I wasn't moving my legs at all. The doctors were notified, and they checked it out and started sticking my feet and legs with this tool they had. I felt nothing. My feet had just dropped to a downward position called toe drop; I could not move them at all. The decision was then to put casts on both legs to hold my feet in position. They had to put an iron bar in the heel of the cast to keep it from tipping to one side. I could not even turn over on my own now. The discovery was made that I was paralyzed from the waist down. The talk I

heard was I would never walk again and would be in Lakeville until I died; and they predicted I would not live past age sixteen. I talked constantly to my parents in heaven. School was my salvation. Books were my love.

When they changed the cast after six months it was discovered that I had a skin abrasion in the center of my back, which had been draining. They put a different cast on with a hole in the back so they could change the dressing. One day I woke with a high fever and was very sick. The doctors started talking about procedures they could do to take care of this drainage. Again it was back to the operating room. The last thing I remember before going under the ether was Dr. Van Garden telling me, "Gale, I am really sorry you're here again. I promise you this will be the last time you will ever have to undergo surgery." They had to keep me on the women's ward in the private room. Each day the nurse would come in change the dressing and pour a solution of some kind in the opening in my back. To me it felt like they were filling a very big hole. The hole in my back healed up really well and never was a problem again. I went back to the children's ward again and back to school but without hope of ever walking again.

Dr. Van Garden was wrong about my not needing surgery again, but right about my not needing surgery on my back. I woke up one evening with severe pain in my right side. Yes, it was my appendix. This surgery was done by one of the staff doctors. My appendix was removed but the scar never healed. It had a drain that stayed opened and had a discharge. The dressing was changed every day. I remember being a little scared as my friend Angie who died had lots of sores on her body. I had also got what they called pressure sores on my legs from the casts. They changed the casts and put on removable ones; to my relief, the sores healed. The one that was from my appendix surgery did not.

We were affected by World War II in the hospital. A lot of the staff went off the war. The ones remaining were always talking about being overworked and how some of them were going to leave and go to work in a defense plant.

It was apparent to me that I would not be leaving the hospital anytime soon. The shortage of staff continued and the air raids and blackouts were many. They would take us out of our beds and put us on the floor during the drills. Many times we could hear planes going over and my heart

would beat faster. I can honestly say it was the one time when they told us not to talk that I didn't. They told us we had to go under the beds and be quiet so that if the Germans or Japanese came they wouldn't know we were there. The nurses came around with their flashlights, which now had black cloth over the light; they would ask us our name and we would whisper it back to them.

During the daytime when we would be out on the porch, Mrs. Tommie would teach us patriotic songs such as *Anchors Away*, The Air Force song, and a lot of others. I was able to tell all the parts of the airplane and what responsibility each person had that flew the war planes.

My cousin Ralph was in the Air Force, and when he would come to visit, I would have one of the kids put the phonograph on and play the Air Force song. He said he liked it, and I would feel so proud having him visit in his uniform. Ralph was my first love; I would daydream about someday getting married to him. One day he visited with his bride-to-be, and I was so disappointed that I turned my face into the bed and would not speak to him. I did eventually get over this.

I didn't like not being able to move or hearing the nurses say I would never walk; it made me feel so sad. I would miss my friends Angie and Phyllis a lot as I would lie in the bed. I had made new friends but it was not the same.

MY PRAYERS BEGIN TO UNFOLD

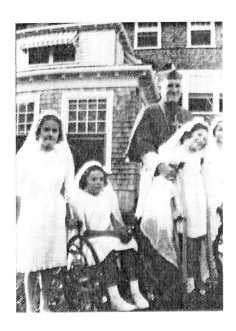

I was to turn twelve this year and just as the priest had prepared me for my first Communion, it was now time to be prepared for Confirmation. Again, Aunty Catherine made my white dress and my veil. The big excitement was that Archbishop Cushing of Boston would be coming to administer Confirmation.

We were well prepared for this, and when the big day came, those of us to receive the confirmation were wheeled to the same auditorium were we went for movies. I was in a

wheelchair as I was still paralyzed; some of the other children were on stretchers. Ralph Murray, my handsome cousin in the Air Force, was to be my sponsor for confirmation. Eunice and Ginnie, my aunts/sisters by adoption, were also there. My special parents were there. I knew this because when they were present I would feel a soft, gentle breeze. The Archbishop was two hours late; they kept giving us updates of where he was and when he'd arrive.

They suggested that if anyone had brought gifts they should give them out while we were waiting. Eunice brought me a beautiful gold ring that had been given to her for her confirmation. Ralph gave me a new prayer book and some pearl rosary beads. Ginnie brought me a gold cross. It finally was announced that the Archbishop was arriving; excitement filled the auditorium. We had been told before that he would give us all a chance to kiss his ring and that it was a very big honor to be able to do that. He walked in; he was a tall man dressed in his special garments. He stopped by each of us and asked our name and held his hand out for us to kiss his ring. I felt so holy at that moment. The ceremony of Confirmation took place;

and the Archbishop had his picture taken with each of us. He told us to be good and not to forget our prayers. He hugged us and said goodbye. This day is still embedded in my mind as one of the best.

The routine of the hospital continued as usual. I was now in the sixth grade and still had the same enthusiasm for school. I could not get enough books to read. I made the honor roll every year since I started school. I would read books all summer, and at the start of school in September, I would get certificates for every five books I read.

The doctors would make rounds with the surgeon, Dr. Van Garden, each month and discuss if they thought there was anything that they could do for me. They would take out a tool they carried in their white coat pocket. It had a hard rubber on one end, and they would tap my knees to check for reflexes. I would be sitting on the edge of the bed with my limp legs hanging down. Then, they would stick me with a sharp, pointed instrument and ask if I could feel it. I was so nervous watching them do this that I really didn't know if I could feel it at all. So then Miss Dickey would put her hands over my eyes, and they would do the same thing, and then they would prick my hand with it and I

would yell ouch. They talked as if I wasn't there as they discussed the fact that I could not be helped. They repeated what I had heard before—that I would not live past sixteen. This was so frightening to hear over again. I had visions of being wheeled to that morgue in the basement. When they would leave I would have a very long talk with God, and when I got through, I knew deep in my heart that I would live a long time and walk.

On one of the monthly visits the discussion was about the way they were treating the children and adults who had polio. When this epidemic struck in the 1940s they opened up the hospital's West Ward area, which was in a different place than I was. (The building I was in was called the East Ward.) Some that were being treated for polio were in these big iron tubes, called Iron Lungs, and many were in wheelchairs and couldn't move many parts of their bodies. There was a new doctor with the group this month; his name was Dr. Morton and he was called the polio doctor. He did the same things they did every month with the tool and moving the legs and feet, but he had a different viewpoint. He suggested that they try the same treatment for me that was used on the polio victims.

Aunty Catherine was consulted about the new therapy; she asked if they thought I had contacted polio. They told her it could be a possibility.

It was learned later that during the second spinal fusion, the doctor cut in too deep and hit the central nervous system causing the paralysis. This was very upsetting to Aunty Catherine. She told me in later years that she wanted to sue the doctor for such negligence; this was not possible as I was a ward of the state.

Two weeks later I was brought over to the therapy building. I was in awe of all the equipment that was there: bicycles, tables, heat lamps, bars to hold onto to help you walk and a big oval-shaped metal tub called a whirlpool. I heard one of the therapists comment that my eyes were as big as saucers as I looked around the room. Watching all the therapy that was going on and seeing them lift a person from the table and stand them between the bars and watching them take a step, I knew right then and there that I could do the same.

The therapist explained that what was happening was called physiotherapy (physical therapy today). She said I had a lot of hard work to do if I was going to walk, but most

of all I had to really want to do it. She started by rubbing oil into my legs and feet; after that she would place them under the heat lamp for fifteen minutes. She would then start moving my foot up and down and then work on my knee, and then the other foot and knee. This procedure was done for two months before I started to get some feeling in my left foot and leg. This occurrence was not only a joy for me but for the entire medical staff as well. During the third month I was put into the whirlpool where I could move my legs freely. Another month passed and I moved on to the stationary bicycle. This was the hardest task of all, and I would become very restless just sitting there peddling. They put together a contraption to attach to the bicycle that would hold a book so I was able to read while I cycled. Sometimes I would be all alone as the others therapies would be over for the day. The therapist sat in her office, which had a big window so she could keep an eye on me. I was really coming along very well.

Dr. Morton was checking on me during one of his weekly rounds and he said, "Today we are going to stand up, little one." It was a very strange feeling; I now had feeling in my left leg and in my right one just a little below

my knee. My right foot had no feeling at all. He held me up on one side and Miss Dickey on the other. It was apparent that my right leg was quite a bit shorter than my left and that the right foot had not responded to the therapy and had what was called foot drop or toe drop. This meant back to the operating room where they stabilized my right foot so it doesn't move back and forth. After this surgery I was then measured for braces and had to have a lift on my right shoe to make up for the difference in the size and so I wouldn't walk with a limp. Crutches were mentioned and I started crying that I didn't want them. I said I would try real hard to walk with the braces, and I could hold on to the bars of the beds until I got balanced. They did listen and let me have my way with that. It was a struggle until I mastered it and then I could move very quickly. I took a few stumbles but would just get right up and try again. I did a lot of talking to God and asking Him to hold my hand and help me as I walked, and He did.

They decided to remove the cast and put me in a back brace. This was much better than the plaster cast and much lighter. Aunty Catherine, who visited a lot and was the one who signed all the papers for my surgery, seemed to always

find something else that needed taken care of. I had a large space between my front teeth, which I didn't mind at all. I would roll up some string and stick it in the space and tell the kids I grew a tooth. Aunty Catherine had other ideas. I saw her signing more papers and next thing I knew I was in the dentist office having these ugly looking metal braces put on my teeth. The procedure made my mouth very sore and swollen. I could barely open up my mouth for several days. I had to drink lots of liquids. Of course, today I am very thankful for all the papers Aunty Catherine signed. I tell my children that I was the first Heavy Metal Star, metal braces on my legs, back, and teeth. I sure would have never made it past the airport security machines.

I graduated from the eigth grade and was so proud to be able to walk to my graduation. Aunty Catherine made me a pink taffeta dress. I wore my hair in a page boy, which was the style at the time. There were four of us who graduated, including my friend Angie. Although she was older than I was, she had missed a lot of school because she had been very sick. Because of not having a hometown where I lived, it was not possible for the teachers to get

material for me to go further, so I had to take correspondence courses for the next two years.

MY THOUGHTS ABOUT LEAVING LAKEVILLE

I would sit on the bench on the porch or lie in my bed during rest hour and wonder what it was like on the outside. What do houses look like inside? What is it like to eat in a restaurant, go to a movie theatre, or go to a real church? What would the school be like that I would attend? How many kids would there be? I was used to only two or four at the most in my classes and now with the correspondence course it was just me and the teacher. Another big thought was what it would feel like to ride in a car? Not being quite three when I entered the hospital, I had no memory of this.

So many things and so many places I knew nothing about. Would this ever happen? I didn't really have the desire to leave, as this was my home, but I did wonder.

My birthday came around again, and Ginnie came with her mother-in-law Nana Reed. It was raining so hard you could hardly see out the windows, but they were here with my birthday cake and presents. I remember telling Ginnie she was getting fat. She had a brown and white checked dress on and looked so pretty, but her stomach was sticking far out in front. She told me that she was going to have a baby in January. I was so excited. I asked her if it was a boy or girl, and she said she didn't know. Of course, all the questions about how the baby got in her stomach came up. I don't recall what answers I was given, but it didn't matter. I prayed to God to send Ginnie a baby girl. I couldn't understand what you would do with a boy baby. After all, the dolls I had were all girl dolls.

When I told Miss Dickey about the baby she asked me if I would like to learn how to knit. She asked what color yarn I would like, and of course, I said pink as I was sure the baby would be a girl. She took money from my account and came in the next day with yarn and knitting

needles and a book with a pattern for booties a sweater and a bonnet. She gave me some orange yarn to practice with and learn the stitches; it took very little time for me to learn. In just a couple of days I was able to start on the outfit for the baby, and I kept at it until it was all finished. I was so proud of what I had accomplished and it was so very tiny and the softest shade of pink. I couldn't wait for the baby to come so I could give it to her.

Thanksgiving, Christmas, and then it was January of 1946 and on the fifteenth of that month Marjorie Helen Reed was born. Gordon called the hospital to tell them so I would know right away. The attendant on duty helped me wrap up the outfit, and they got it in the mail the very next day.

They sent a picture of the baby. She was so beautiful; she had very black hair and beautiful blue eyes and was really round and plump. I would run my fingers over the pictures to see if I could feel her and wish I could see her for real. The hospital rules were no one under twelve could visit. Oh God, I thought, I have to get better so I can leave here and see the baby. I want to touch her and hold her and sing to her. The following June, Ginnie,

Gordon and Nana Reed came to visit with the baby. They got special permission for me to walk down the ramp to the car to see her and touch her. Her black hair had disappeared and it was now a golden brown, her eyes were so blue, and when I touched her she was so very soft and smooth. She smiled at me. My heart just danced and I started to cry. I wanted to go home with them, the first time I ever thought about leaving. I stopped crying quickly as it was making the baby cry. She was wearing the pink sweater and booties I made her. The hat didn't fit anymore; she had a lot of hair. When I touched her hand she wrapped her little fingers around mine, and my heart felt as though it would burst. I loved this baby so much and how I wanted to leave with them when they left.

As they were driving away, I was following them inside the porch and the tears were rolling down my face. I stopped for a moment and said, "God, you have got to help me get out of here." I immediately went and said my rosary and prayed most of the day. I wanted to be with Marjie so much.

I had a lot more things to do before I could leave. I still needed to be able to walk without braces on my legs,

and they had a lot of concern as to why my appendix scar continued to drain. I went to bed that night with a heavy heart. I had trouble sleeping and started to think about some of the staff and what part they had played in my life all these years. Some of them were not so good to me and others left a real imprint on my heart to this day. The hospital was my home and they were my family.

MY HOSPITAL FAMILY

There were many staff members who really made an impression on me at the hospital. Some of them were a positive influence and others were not. I know that I learned from both personalities even though at times it was painful.

Miss Dickey: She was the head nurse at the hospital in charge of both the boys' and girls' wards. She was only about five feet tall, had white hair that was pulled up in a bun on the top of her head, upon which sat a sheer white cap with a black band around it. She told us it was the cap that nurses wore when they graduated from the Massachusetts General Hospital Nursing School in Boston.

Her eyes were ice blue. She always wore a long sleeved uniform and black leather boots that came halfway up the calf of her leg. Miss Dickey very seldom smiled. She was one of the faces I would see when I was younger and was frightened by the witches.

Miss Dickey would make her rounds each morning and would go over what was reported from the night before. She would hear I was reading a book under my covers with

a flashlight and wanted to know where I had gotten the flashlight. I told her I got it from Eunice when she visited. She would hold out her hand, and I would reach into one of the pockets on the bed and hand her the flashlight. She would then move to the next bed, and I would stick my tongue out at her; the kids would laugh and it was off to solitary for the day for me. I would be allowed to attend school, but that was all. My bed was placed in the room with all the metal lockers for the day. At the end of the day, I would promise to be good and I would be returned to the ward.

It seemed as though I could never be good enough for Miss Dickey. It was Tuesday afternoon and time for the movies. I was on the stretcher ready to go. The girl next to me asked me a question that I answered and Miss Dickey was standing nearby. She asked, "Gale, was that you talking?" and in the back of my mind I remembered her saying we would never get punished if we told the truth so I admitted to talking and Miss Dickey told the orderly to take me back to my bed. I knew then that I would never trust her with the truth again. It made it hard for me when I went to confession once a month as I would have to tell the priest

98

that I lied. He would just tell me to say Our Fathers and Hail Marys, and seeing as that was one of my favorite things to do I didn't mind at all. When I was to leave the hospital, she told Ginnie and Gordon that I was real bad and they would have to watch me. She also told me I was boy crazy because I had a boyfriend at the hospital, which was not acceptable but the interesting thing was we just wrote letters and the better staff would deliver them back and forth. Our secret was not to let Miss Dickey know about it. The better side of Miss Dickey was she taught me to knit and crochet and make puzzles. She tried not to let you fail at anything and her favorite saying when any of us got discouraged was, "I think I can, I think I can, I know I can." She told us that is what the little engine said.

I always remembered what Miss Dickey said to me when my friend Angie died, "Only the good die young." I heard a few years after I left the hospital that Miss Dickey was well in her nineties when she died. I still think about her statement to me and wonder if she felt that it applied to her.

Miss Buttercup: One of the attendants that I would like to forget, she was very cruel to all of us. She was a

very stern looking lady with glasses and blond hair. She always looked neat and would wear a handkerchief in the pocket of her uniform that would have a large embroidered edge on it. One of the children had made it for her. Unfortunately, she didn't treat her nicely either. One evening she was forcing one of the younger children to eat her supper. The child was only four years old at the time; Miss Buttercup's favorite thing to do if we wouldn't eat was to push our face into our food. I started to pray and ask God to please make her stop. Little Ellie was screaming, and her little face was covered with food and was bright red. I decided that I would tell Miss Dickey on her in the morning as it was not fair to treat little children that way. Ellie was vomiting all night. Miss Dickey listened and didn't say too much. The following night Miss Buttercup was again on duty. She came walking in the ward and looked directly at me. Her eyes had fire in them. She asked, "Did you tattle on me today?" I said yes, too frightened to lie to her. She said, "I will show you what happens to kids who tattle on me." She untied the apron strap from around me and picked me up by the neck of the cast and the bar between my legs, put me on the floor, and dragged me

holding onto the bar, my head banging along the floor, my hair getting all snarled up and feeling as though it was being pulled out from rubbing on the floor. I was too frightened to even cry. I had no idea what her plan was for me.

When she reached the area with the bathtubs and showers, she turned on the shower and laid me in the small area. I just fit and had no room to move at all. She turned the shower on real hard and the cold water came blasting in my face. I would try to turn my face as I thought I would drown. There was no room for me to move, and I would be spitting and choking on the water that was filling my nose and mouth. After what seemed like hours to me, she would ask "Have you had enough?" shutting off the shower. It would take a minute or two for me to get my breath. Well, it wasn't fast enough for her and on with the shower again. When she turned it off the second time I would answer her real quickly. She would lift me out and dry me off and tell me that I better not tattle on her tomorrow or I would get worse the following night. When I got back to the ward, the kids would be waiting for me to tell them what happened but I was not telling anything. I knew that if I told anyone,

they would get the same treatment. I had seen this happen before and I was not taking a chance.

On another occasion when I was up and walking around, I was using the bathroom and I could hear a scuffle going on outside, so I peeked down under the stall and Miss Buttercup was holding one of the children's heads under water in the sink that she had filled up. She caught me peeking and she took the other kid back to the ward. When she came back I was washing my hands, and she grabbed me by the hair and said you just don't know enough to mind your own business. She filled up the sink and held my head under the water. There was no escaping this mean woman. She had full control to do whatever she chose to. I wanted to tell my family, but I had already tried that and I ended up in more trouble.

I had a hard time eating meat if it had fat in it (our meat was always ground up). Miss Buttercup would take the plate put it in the refrigerator, and when the rest of the staff went off duty, she would force me to eat the meat. She would pull a hunk of my hair until I did. When I started shoveling the meat in, she would leave. I learned to take the meat and pack it down in the side of my bed; my bed

was one that could be cranked up so it had a nice little place for storing. Then, it would just dry up and I would pick it out when we were moved out onto the porch. I wrote a post card to Eunice about the treatment, not giving thought that the mail was put in a tray in the kitchen and the staff had the privilege of reading it. One night about ten the nurse on duty that evening, Miss Shovel, came with a flashlight, a pencil, and the post card and told me to erase what I wrote and to write something nice. I said, "No." She grabbed me by the braid in my hair and pulled it real hard until I finally gave in and erased it. Aunty Eunice could read some of the old writing and she came to talk to Miss Dickey. She was told that I loved to make up stories and that I had a big imagination. In fact, they called me the storyteller of the girls' ward. She assured Aunty Eunice that the staff was very good to the children and not to worry. Aunty Eunice said she believed me but to try harder to be good. I began to cry and asked her if she would take me home. Her eyes filled up and she said, "I would love to honey, but I can't right now. But one day I will." I believed her.

After that when I had the urge to tell on the staff, I would talk to God and the blessed Mother and tell them I

knew they would keep my secret. We would all talk about how we wished Miss Buttercup would leave. I even would have the other kids saying the rosary with me and praying to God.

One day Miss Buttercup and Miss Dickey got into a fight in the girls' bathroom. There were large, tin cans in the bathroom with disinfectant in them to put the sheets in that got soiled. A couple of us kids were washing up and brushing our teeth. We tried not to look. Miss Buttercup got so out of control that she picked up Miss Dickey and dumped her in one of the big cans with the disinfectant. I ran out and got Miss Currie, the second charge nurse. She came in and helped Miss Dickey; Miss Buttercup left the room and we never saw her again at the hospital. For the first time Miss Dickey thanked me and told me I was a good girl.

I was really affected by the way Miss Buttercup treated me. Many years after leaving the hospital I was unable to go into a shower. I never did learn to swim, and water became a big fear. I would not be able to catch my breath, and it would scare me. I can go into a shower now.

I learned by turning the water on before I entered it was possible.

Tommy R: This man made up for the mean staff at the hospital. He was always cheerful and would keep us entertained when he would do his work. He was a short man with grey hair, a little mustache, and a twinkle in his eyes. Tommy worked in the kitchen getting the trays ready for meals. He started at six a.m. He would set up the trays, pour the orange juice, and make the toast and pour melted butter over it. He also would sweep the floors and polish them with a big machine. The floors were a medium brown color, and when Tommy would get through polishing them, they would be so shiny that you could see your face in them. He loved to make up what he called jingles for us, and he would do this by using our names and making silly things rhyme with it. My special jingle was:

> Gale, Gale, she looks so pale
> She never eats spinach
> She always eats kale
> When she's sick
> She uses the garbage pail.

No matter how many times I would hear this jingle I would laugh and laugh, and Tommy never tired of saying it. He had a special one for everyone. When I was up and walking around again, I was able to help Tommy out in the kitchen in the morning. I would get the trays ready with him and squeeze the fresh orange juice. I learned that it took three oranges to fill a cup. He would always tell me to check for seeds, and then he would double check as he didn't want anyone to choke. My favorite thing was buttering the toast. He would melt the butter and pour it in a bowl, and I would take a spoon and drizzle it over the toast. He told me one day I was the best helper that he had. I know I walked taller that day.

One day I noticed that Tommy wasn't around for awhile. I thought he might be on vacation but he never did come back. I heard the staff talking, and they mentioned that he had a heart attack and died on the way to work. I felt so sad and started to cry. I always felt safe when I would know that Tommy was around. I asked God to be really good to him in heaven and to make sure he had a lot of toast to eat and juice to drink.

Many other staff members left an imprint on my heart, one was **Mrs. Tommie,** who taught us a lot of songs and we would have sing-a-longs when she was on duty. She had a beautiful voice and was very kind. Because of her I knew just about every song that was popular during the World War II era.

Then there was **Miss Zee;** she was very special. When she was on duty for rest hour, she would come to my bed and whisper my name and then would hand me a cup of the most delicious drink called Pepsi Cola. I loved the way it would fizz and the bubbles would tickle my nose. She would just do this in the summer time. It is still my favorite drink, sort of like comfort food for me. Miss Zee was a pretty redhead, and I would make lots of crocheted edge handkerchiefs for her to wear in the pocket of her uniform.

Another favorite was Miss Currie; she was in charge on the days that Miss Dickey was off. She was tall and heavy. You could always tell when she was coming to the ward; she would be humming a song. She would give me a piece of candy even if I didn't finish my dinner. I could always depend on a kind word from her and a pat on the

arm that she called a hug. She would say you can't feel a hug through all that plaster.

Miss Pelican: She was the social worker, a very comical looking and acting lady. Just seeing her would make me laugh. She would start waving and yelling "Hello there Gale!" before she would be in the ward. Her complexion was dark and her eyes were like black marbles. She had a very large nose and mouth. She always wore a pleated skirt and a tweed jacket and flat-tie oxford shoes. I must not forget she always wore a beret. Her smile stretched across her face, and she would come with news of having seen my Ginnie at the North Reading hospital; she would reach into her black briefcase and pull out a letter from Ginnie. I liked it when Miss Pelican came to the hospital; she always had something good to say and bring.

Miss Tibby: The occupational therapist at the hospital and someone who was very important in my life. Her teachings inspire and influence me even to this day. Miss Tibby was a tall, thin lady with glasses and very short, grey hair. She had the sweetest disposition. She never got upset with us and her patience was phenomenal. Miss Tibby explained to us that occupational therapy was a form

of treatment that would teach us to use our hands and learn skills to keep our minds occupied; this would help us after we left the hospital.

One of the first skills I learned was how to sew. The treadle machine was the first sewing machine that I used. The first project I worked on was a skirt; the material was heavy broadcloth and was mustard yellow. It was a very full skirt and around the bottom I sewed large red, green, and blue rick-rack. Miss Tibby suggested that I make a picture style hat to go with it. I made the hat and put the same trim on it. When I tried it on Miss Tibby said I looked like a little flower. I was so pleased with myself and really liked this treatment called OT.

I was excited when Aunty Catherine came to visit. She made all of my clothes for me; I could hardly wait to show her what I had made. She was very proud of me and told me that I should keep sewing because I had done a really good job.

Miss Tibby was also responsible for the weenie roasts. We were allowed to roast our own hot dogs by holding them on a long metal fork in the fireplace that was built of rocks. I liked mine really blackened. Sometimes I

would hold them so long over the fire I would lose them. After the toasting of marshmallows we would gather together and play games. Of course, all of us girls would get shy or giddy because we would be interacting with the boys; this didn't happen very often so we didn't have much opportunity to get used to it.

The OT program meant many things to me. I loved to make gifts for my aunts and the nurses at the hospital. The wood projects were fun. I liked the smell of the wood when you would sand it and then the shiny finish after staining and putting on a coat of shellac. Time would go by so quickly when I was part of this group. One of the other fun things we did in OT was to just sit in a circle and make funny faces, and Miss Tibby would give a prize to the one who made the funniest. I received many of these prizes since making people laugh was what I liked the most. Miss Tibby could make some pretty silly faces also. We learned to play cards and board games and to socialize in a mixed group. I would think about what I wanted to be when I grew up and left the hospital; sometimes it was a nurse, but most of the time it was to be an occupational therapist just like Miss Tibby (and indeed I did eventually work as an

Occupational Therapist for 26 years). There was another lady who taught the program named Miss Buttons; she was younger than Miss Tibby and very nice. She taught us how to work with Plexiglas. It was a new product that looked like glass but it didn't break as easily. I was working on a picture frame. The smell of the Plexiglas when it was sanded was not a pleasant one like the wood and a lot harder to sand. I had only one more piece to finish before putting it together. There wasn't any OT on the weekend so I waited for Monday afternoon to come so I could finish my project. Miss Buttons never came back. She had gone away for the weekend and had drowned in the ocean. Miss Tibby said she would help me finish my project, but I never did. I felt sad when I would try to work on it. I told Miss Tibby I didn't want to finish it. It was so hard to understand why people had to die. Sometimes we would talk about what the outside world was like; I would feel both excited and scared. I still was undecided about leaving except to be able to be with the new baby Marjie.

PREPARING TO LEAVE

The next two years were spent in physical therapy learning how to walk without the braces. It was not painful, although it did take a lot of practice and some days it seemed as though I was getting nowhere. The doctors and

nurses could see the improvement; it was hard for me as I was impatient and just wanted to walk now.

I continued to take correspondence courses and to read books during the summers. I had a beautiful library of books that relatives had brought to me, and I read them over many times. *Black Beauty* was one of my favorites; the Cherry Ames nurse series were also favorites with me. I still would dream of becoming a nurse and helping others.

It was decided that I would be taken off the hospital grounds to the town of Middleboro so I could have an idea of what the world was like outside the hospital. Miss Pelican, the social worker, was unavailable; they sent a new social worker named Mrs. Mac to take me. I was excited about the trip. I had my first ride in a car (not remembering my last ride at age three). I was so excited sitting there watching the trees go flying by and the cars sometimes passing us. The first thing we did was go to a clothing store just to look at all the different clothes. Next, we went to a shoe store and then the most exciting place was the ice cream parlor. I had no idea what to order. Mrs. Mac tried to tell me about a soda, a banana split, and a frappe. It all seemed overwhelming to me; I told her that I would have

whatever she had. Her choice was a coffee ice cream soda; I never had anything that tasted so good. I noticed her watching me a few times, and she would ask if I was enjoying it, and I would shake my head yes and did not speak until I was finished. We then drove back to the hospital. I look back today, and I think here I was fourteen years old having my first ride in a car and my first trip to the store and the best of all my first ice cream soda. How happy I was on that day. I wondered if Mrs. Mac was going to take me again and to my surprise she said yes. This happened about once a month for the last year I was in the hospital. By this time I was able to order my own sodas.

I had the braces removed but had to continue to wear the six-inch lift on my right shoe as my right leg was shorter than the left. I had feeling back in the left leg but it didn't return in the right one from just below the knee down, and the leg itself was much thinner. I still wore the brace on my back, and the doctors said when I did leave the hospital I would have to wear it for awhile. The other problem was that my appendix scar never healed. It continued to have an open sore that had some drainage coming out of it. This

had to be taken care of on a daily basis and would have to be looked into when I did leave the hospital.

The decision had to be made as to where I would live when I left the hospital. Aunty Catherine was in her late seventies, and she had a bad heart and would be unable to take care of me on the outside. Deep in my heart I wanted to go and live with Ginnie and Gordon so I could be with baby Marjie, and I would pray to God and ask Him to please help make this happen. Aunty Catherine was making plans to send me to a Catholic orphanage as she knew it was impossible for her to take me. When Gordon, who was Ginnie's husband, heard this it disturbed him; he asked why he and Ginnie couldn't take me. Aunty Catherine said for this to happen that she would have to give up guardianship, and Ginnie would have to take over. From what I was told this would not be a problem for Ginnie and Gordon; they both felt that I had been institutionalized long enough and that I shouldn't have to be put in another one. The plans were made and put into action; the first thing that happened was the guardianship change.

The next decision was up to the state; although Aunty Catherine was guardian over me, I was still considered to be

a ward of the State of Massachusetts. They would do a thorough investigation into the life of Ginnie and Gordon to see if they felt they were qualified. This meant going to their home and checking everything out. When they realized that Ginnie had been in a hospital for tuberculosis of the lungs and that she went for treatments to keep her lung from collapsing, they felt that taking care of me was too much of a responsibility for her health-wise. They also told them that I would have to have my own room, and they only had a two bedroom house. Another observation and suggestion was that she would need someone to help her take care of me as she needed to watch her health and taking care of an extra person plus a teenager was too much.

More plans were made; Aunty Catherine would give Ginnie and Gordon money to add two more bedrooms to their home, and Gordon's mom would come and live with them. Plans were also made for a visiting nurse to come in for a month and teach Ginnie how to change the dressing on my stomach from my appendix scar. With all of this in place, a date was set for me to leave the hospital on October 5, 1948.

I began to wonder if this was going to be like my dreams where Aunty Eunice would come to take me home and I would walk down the ramp to get in the car and the car would disappear. I dreamt this so many times over and over. Would this happen on October 5th in 1948?

The first of October the staff had a big party for me. There was a big cake and lots of presents and cards as well as much talk about what it was like on the outside world. Each staff person started telling me things that they would remember about me. My smile seemed to be top on the list and my devilish nature. They talked about how strong I was and my dedication to God and the Blessed Mother, and they mentioned that my faith is what helped me through so many tough times. They wanted to know who was going to lead the sing-a-long when I left. I knew so many songs that they didn't know.

They wanted to tell me about all the new things I would experience and deep inside I was beginning to feel lonely and scared. They all kept telling me I would be discovering things on the outside that kids my age had been aware of for a very long time. They guaranteed me that the outside world was an exciting one and I would love it.

117

Aunty Catherine told Miss Dickey that she did not want me to bring any of my belongings home. She would bring a new outfit for me to go home in or send it with Ginnie. I was to leave all my clothes, toys, and books at the hospital. To keep me busy the last few days I was asked to write in all my books: dedicated to Lakeville State Sanatorium by Gale Logan. I never realized how many books that I had. I felt proud that I was able to leave them for the other kids.

I didn't feel so good about leaving my dolls. It never occurred to me that I would have to leave my upside down doll. This was the hardest thing for me to do. I would pray to God at night not to let this happen. All my crying and pleading did not do me any good; the decision had been made, including the one about my upside down doll Marianne.

Ginnie and Gordon came to pick me up on a beautiful fall day; I was filled with wonder of what was to come. I said goodbye to all the staff, including Mrs. Jay, my teacher, and Miss Tibby, the OT lady. They were the hardest ones to say goodbye to. Mrs. Jay told me that I would love school and that I had nothing to worry about

because I was a very smart girl. Miss Dickey said goodbye and told me not to be bad like I was at the hospital. She just couldn't be nice. I took a risk and stuck my tongue out at her as I knew she couldn't do anything about it. I was leaving.

As I walked down the ramp I began to feel anxious for fear that the car would disappear like in my dreams. It didn't and Gordon opened the back door for me. I asked where Marjie was, and they said she was home in Malden waiting for me with Nana Reed, Gordon's mother, who was cooking supper for us. It was a very long ride to Malden, about three hours from the hospital. Going through Boston was scary. The elevator trains overhead made so much noise; Gordon would laugh when I would duck my head when the trains would go by; I was so frightened my stomach felt like I was going to be sick. I know he didn't understand how scary it was for me. I had a new pocketbook that Ginnie brought me, and I had my rosary beads inside of it so I got them out and started saying them as it always made me feel better. I never saw so many houses and stores and cars. It was so hard to believe that this was what it looked like outside of the small world of

the hospital where I had been living for the past twelve years. How little this fourteen year old knew about this world. All the smells in the air were so different; I really was bothered by the exhaust from the cars. I was used to the smell of flowers and trees and grass, and this was a foreign smell to my nose. The trees along the roads were really pretty; the leaves were turning beautiful colors and the air was nice and crisp. We were fast approaching Lincoln Street in Malden, Massachusetts where I was to live for the next six years.

When I got out of the car my heart was beating really fast. I walked up the backstairs to the hallway and realized this was the first time I ever walked up stairs that I remembered; the hospital only had ramps; there were no stairs. I could smell the food that was being cooked, something that was also new as our food was brought over from the main kitchen in a steam cart; the only food I remember smelling was toast. The door opened and there stood Nana Reed and Marjie. She was just one and a half years old; she was as happy to see me as I was to see her. The bond between Marjie and I was one that would last forever. Nana Reed gave me a big welcoming hug and said,

"Come in. This is your new home." I remember it looking so very small to me compared to the large, open wards of the hospital. The rooms were all different sizes and very small. Ginnie took me upstairs to show me my room and Nana Reed's room that was across the hall. It was a good size room but seemed so far away from everyone except Nana Reed. Ginnie showed me the closet with new clothes in it and the draws of nightgowns, underwear, and socks. We then went downstairs for dinner. Nana had cooked a pot roast. She had the meat in a platter on the table and also the vegetables and bread and butter. This was a new experience for me; our food was always on our plates when we got it, and I had never put my own food on a plate. My bread always came buttered and the food was never hot. I had to let my food stay on my plate until it got cool. When Ginnie took me to my first doctor's visit, she told him I had an eating problem. He asked me if I missed the hospital cooking, and I said "No, I like the cooking but it is too hot." Nana had made a nice chocolate cake and we had ice cream with it. I was really quite full. I asked if I could help with the dishes, and they said not today as it was my first day. It was around seven thirty when we finished eating. Ginnie

said I should get washed up and go put my nightgown and robe on and then come back downstairs and read a bedtime story to Marjie. When I went into the bathroom I could not believe how small it was. The one in the hospital had eight sinks and four stalls; this one I could just about move around in. Marjie was not about to leave my side. She came in the small bathroom with me as I washed my face and brushed my teeth. She wasn't able to go up the stairs as yet so I went up and got into my nightgown and robe and came down read a story to her and said her prayers and tucked her in bed. I said goodnight to Ginnie, Gordon and Nana Reed, and I went upstairs to my room. I got into the bed, put out the light, and was not prepared for what happened next. I was overwhelmed with loneliness and started crying. I was missing all my friends at the hospital; I was used to saying goodnight to them and talking with them after the lights went out. When Ginnie came upstairs to make sure I got to bed alright, she saw that I had my head covered up and she lifted the cover off and found me sobbing. She sat on the edge of the bed and asked what was wrong, and I told her I was missing my friends, and I was very lonely and wished I had my upside doll Marianne. I asked if she could write to

the hospital and ask for her. She said that she would do that, but I never did know if she did and I never asked again. I finally fell asleep and was woken up the next morning by Ginnie bringing Marjie up to my room, and she sat on the edge of the bed and brought me one of her dolls for my room.

My cousin Ralph came to take me out to a restaurant; he said he had been waiting for this day for a long time. He drove very fast and would often wave his arm in front of the windshield in the car, and I would ask him what he was doing. His reply was, "Brushing away red lights." It didn't make any sense to me. We got to the restaurant and it looked dark inside to me although it was daytime. I had never been to a restaurant before, just the ice cream place. Ralph ordered my meal, which I ate very little of. I did eat the dessert; it was apple pie and ice cream. We just drove around and then we went back to Ginnie's. She asked if I like going to the restaurant and I said, "No, it is dark in restaurants and the food is too hot."

The day came to register for school. I would be going to a junior high school called Beebe Junior High. The first thing I had to do was to take a test because I had

only gone to the seventh grade in the hospital. I passed the test without any problems and was put into the ninth grade. My classes were all girls, and this made it easier for me but the whole change of being in class with more than two or three girls was very different. I was very quiet and would try to understand all that the other girls were talking about, but there were things that I had never experienced and I knew that they hadn't experienced my way of life. I figured I could learn a lot by just listening. Everyone was very friendly and nice to me. Two girls in particular, who didn't live too far from me, took me under their wing and had a party for me to introduce me to all the other kids. After school we would get together at one of their houses, and they taught me how to dance and also introduced me to some of the boys in their group. One of the girls, named Pricilla, was the best; I spent a lot of time at her house and she helped me learn about the outside world. I went to the dances on Friday nights, and we would go to the movies or just get together and listen to records. I didn't have them over to my house as Ginnie didn't want me to; she said it was best if I learned to go out and socialize.

A lot of my free time was taken up with Marjie; she was like having a real live doll. I would take her for walks in her stroller. We would stop in the store and I would buy her penny candy or some little trinket. I just couldn't be with her enough.

Some of the difficult things for me were when I would walk home from school and the two kids who lived across the street from my house, who were about six and eight years of age, would sit on the sidewalk and chant as I walked by, "Big shoe, big shoe." I would lose my balance and kick the opposite ankle with the lift on my shoe. By the time I walked in the house, my sock would be covered with blood. I would come in the house with tears running down my face, and Ginnie would ask what was wrong. I would tell her and she would go and talk to the parents. It didn't make any difference. I just had to try not to let it bother me. It took awhile but I continued to adjust to the outside world each year.

MY EDUCATION CONTINUES

When I entered Malden High School I was very nervous. I wasn't with my friends that I had made in junior high. There were many junior high schools in Malden and they also attended Malden High. I had to make new friends all over again. The first day of school was difficult because we had to change classes for each period and some were on different floors. Walking up the stairs carrying books was very difficult for me as I needed to hold the railings in order to balance myself. This was hard as my right shoe was very heavy and it would throw me off balance easily. So carrying the heavy load of books and trying to hold them in one hand was not an easy task. My leg and back would get very tired and the open sore on my side was starting to drain more. Ginnie went and spoke to the guidance counselor, who told her that she would have to get a letter from my doctor telling them that this was a problem. Ginnie had to take me for my six-month checkup and talked to the doctor, and they said they would be glad to give her a letter. They also had another plan. A new drug had come out to stop drainage in open sores, and they wanted to use it on me; this

would mean being re-admitted to the hospital again for three to four months. I started to cry. I begged them not to send me back, but of course I had no choice. I had been having a lot of problems with the drain backing up into my ovaries. When it was time for my monthly period, I would have to be put on codeine for three days so I could tolerate the pain. The decision was made that I would go and take the new treatment. The school situation would be tabled until I came home again. In the meantime they would make plans for my schoolwork and books to be sent to the hospital, and the teachers would then be able to work with me and keep me up with my class.

One month later I went back to Lakeville Hospital, but this time it was different. I was now sixteen and had to be put in the women's ward. I was immediately started on the treatment: a combination of penicillin in oil and streptomycin. This meant two shots of the penicillin mixture a day and three a day of the streptomycin. At the end of one month my bottom was very sore, my hair was falling out in big clumps, and my eyesight had become very blurry. The doctors had a discussion one day and decided that they should give me the new batch of streptomycin as

they had eliminated the side effects of hair loss and blurred vision. I was missing Marjie a lot; we had become so close. Ginnie said she was crying for me at night to read to her and couldn't understand why I wasn't there. Sometimes I would hear her calling to me. I said my rosary to the Blessed Mother each day, asking her to keep Marjie safe and make my drainage stop. The drainage did stop during the second month of treatment. I asked the doctor if I could go home, and he said the treatment was for three months. I entered in January and left in March, so they told the truth about the length of time I would be there. I had kept up with my studies and learned how to do tatting and make pretty lace doilies while I was there. Ginnie was proud of that as she did beautiful tatting; she made tablecloths and doilies and lots of handkerchiefs.

When I did leave in March I did not go back to the high school. Plans were made for me to have a home teacher come in and I would be schooled at home. In the winter I would have school at home; in the spring I would go to the school, and they made sure my classes were on the same floor. In my senior year all classes were on the first floor. This allowed me to complete my full senior year in

school. I graduated from Malden High School in June of 1951.

During my last year of high school, a representative from Massachusetts Rehab came to talk to me and Ginnie as to what I would do after college. He said that they needed to evaluate me for the type of job I would be able to handle due to my disabilities. He started out by asking me what I would like to do. My first choice was to be a nurse. His reply was that was not a good choice as standing on my feet and lifting would not be good for me. My other choices of occupational therapist and hairdresser got the same response. I looked at him, feeling very frustrated and somewhat angry, and asked him to tell me what he thought I should do. His reply was that I should go to business school. Secretarial work would not be a strain on my back or legs as I would be sitting down most of the time. I was enrolled in Malden Business School before I graduated high school. While at business school, I had the opportunity to learn the latest office machine that had come on the market called a comptometer. I would receive a separate certificate along with my diploma when I graduated from the college

after two years. This was appealing to me and I loved running the machine; it was very interesting.

Just before graduation we had the opportunity to go out on job interviews that the school set up for us. I had a real hard time because I had walking pneumonia and did not have a clue about it. I just knew that after being out in the cold crisp air, I would go into a place like a bank or a factory to have my interview and I would start coughing. After about a month of this, Ginnie decided to make an appointment with the doctor and found out that I had a very bad case of lobar pneumonia and had to be put to bed right away. He said I was too sick to go to a hospital. It took three months for me to get better. I was on aspirin and grape juice for the first three months. My fever broke, and my lungs cleared, and the doctor came to make me my first meal. It took me another two months to get back on my feet and gain back the weight I had lost, and then it was back to finish business school.

My first job was for a company in Everett called Kyanize Paint. I worked as a comptometer operator and enjoyed it. I worked there for two years and then a new machine came on the market. It did more than add,

multiply and divide, it also was a typewriter. They called it a billing machine, exciting for some but disappointing for me. I was too short and had to weigh at least 120 pounds to operate it. I was under five feet and I only weighed 85 pounds. They did not have another position so I had to be let go. The hunt for a new job began. I was lucky because the jobs I applied for wanted comptometer operators, and I had no problem passing the tests we had to take. I finally was hired for a job at Whiting's Milk Company in Charlestown, Massacusetts. I would take care of the account for Daisy Meadows, who was the representative for Whiting's Milk. Shortly after that I would be in charge of the accounts payable department. One day a notice came on the board for a private secretary for the credit manager, and I applied for that and I was selected for the job. I had not used my shorthand in two years and was a bit nervous about it, but it wasn't a problem. The credit manager was very patient, and I didn't take too long to get the skill back.

I liked the job because I was my own boss for most of the time. Whiting's had many branches, which were scattered in different towns. My boss spent two or three days each week in a different branch leaving me pretty

much on my own. I could work at my own pace. We kept in touch by phone daily when he was out of the office.

When I applied for the job, he told me that everyone that worked for him found it to be a nice job to have. The only reason they left was because they were getting married and moving away. He then asked if I had a boyfriend that I was serious with and had plans of marriage, and I told him not at the present time.

MARRIAGE AND CHILDREN

I made many new friends at Whiting's. One in particular was a gal named Jane, who continues to be my friend today. She lived in a town called Martha's Vineyard in Cape Cod and had worked in the branch office of Whiting's there, but was transferred to the Charlestown office. We both worked as secretaries and would share our lunch time together. She was staying at a hotel in Boston called the Franklin Square House; it was a hotel for women, and I was fascinated as that is where Ginnie and Eunice lived until they got married. Jane mentioned one day that the area had changed and she was really scared to walk from the train station at night. I told her that there was a YWCA just around the corner from my house. She came home with me one evening for supper, and then we went to the YWCA so she could apply for a room. There was one available, and she just had to have references and approval of her parent. This is how I met another gal named Lois. Lois and Jane were hostesses for the Red Shield Club for servicemen; they asked if I would like to join. They went every Wednesday evening from six to twelve and Sunday

afternoon from twelve to six. I was interested and when I told Ginnie, she was not happy about me being in Boston that late at night. She finally agreed. The club was directed by the Salvation Army. I had to interview with the Major of the Salvation Army before I was accepted. He was very nice and warned me of my social behavior, language, and dress. The most important rule was no dating the servicemen. I would be on probation for one year. The duties were to serve coffee, play shuffleboard, make puzzles, and make sure they were provided with stationery if they wanted to write home. No cards or dancing allowed.

I did real well following the rules and really enjoyed the duties and the conversation with the men who would come in. I felt pretty safe with Lois and Jane there. One Wednesday evening in May of 1954, one of the other hostesses came in with her fiancée. With them was a tall, tanned, blond, blue-eyed sailor with the most beautiful smile. His name was Evan. I asked if he would like some coffee and he said what sailor would say no to coffee, but he insisted on getting it himself. I told him the rules were no customers behind the counter; he laughed and said well this will be a first. I let him pour his own coffee.

We sat and talked, and I found out that he was from Skowhegan, Maine and that he had two brothers and four sisters. He had been in the service for three years and graduated high school in 1951, the same year that I did. He said that his ship, the USS Worcester cl-144, would be leaving for a midshipman's cruise shortly. The other hostess came over and asked me if I could close early as Evan had not been able to find a date and maybe I would like to go out with them. I looked at her and then at him, and he asked if I would like to go to the beach with him and the other couple. I told them I would have to call the Major in order to leave early. I looked around and saw that there were not too many customers; I called the major, and he said it would be okay if I left but to make sure I told the janitor. We were off to Revere Beach for our first date. We rode on the double Ferris wheel, ate hot dogs, and had a great time. Evan dropped the other couple off after the beach and then took me home. He asked if he could see me again, and I was so happy that I gave him my phone number, and he called me the following night and we made plans to go out again. When he came to pick me up he met Ginnie and Gordon. They really seemed to like him.

Gordon had been in the Navy so they had something in common to talk about. We left for yet another beach and picked up some friends of Evan's on the way. We had another nice day.

Evan left on the midshipman's cruise the first of June in 1954; he would be gone until September. We kept in touch by mail. I wrote him every day and he also wrote me. When he returned in September he asked me to marry him. I said yes. We planned to get married the following June.

We became engaged and started making plans for the wedding. Ginnie and Gordon decided to sell the house in Malden. They had found a new single home in Woburn. The house sold real fast. This was a problem for me. Woburn had no transportation to my job and I didn't drive. The wedding plans changed, and we decided to get married before they moved to Woburn. It gave us six weeks to plan the wedding. We set the date for November 13, 1954 on a Sunday. We went to classes as Evan was not Catholic. The priest had drilled into our heads that we could not get married inside the altar gate nor could I receive the special Papal blessing at the end of the ceremony. This was okay with us, but the day of the wedding the priest who married

us was not the same as the one we took lessons from. He insisted that we step inside the altar gate. We both replied, "No." He then told us that he had all afternoon to wait; he would not continue until we stepped inside. He had the same rank when he was in the navy that Evan presently had; they chatted a bit about their navy experiences while the organist was playing a song. We left the church and went to the reception. It seemed like the fastest day of my life. My aunty Catherine and I made my gown. Ginnie had a friend that let me borrow her crown that was imported from Italy. The biggest and hardest part of the day was that I wore high-heeled shoes for the first time. I didn't want to walk down the aisle with my orthopedic shoes with the lift on the right one. I was really glad to get back into those orthopedic shoes after the reception.

I had told Evan before we married that I was unable to have children. This had been told to me by the doctor who treated me for polio at the hospital. He explained to me that my trunk was too short because of the spinal fusions, and this caused my pelvic bone and rib cage to only give me a space of one finger between when the normal space is four. He said it would be an impossible for me to

conceive a child. Evan was not concerned about this when I told him; he said, "We can adopt a baby." He also had little concern about the scars on my back and legs. His comment to that was, "I am sure I have seen worse in the showers on the ship. It was a relief to me as I had been engaged a year before I met Evan and because of the above factors, the person said he could not deal with not having children and broke the engagement.

When we returned from our honeymoon, we moved to the furnished apartment that we had rented in Malden. It was small but cozy and easy for me to access transportation for work. I had not been feeling good and thought I had the flu; I called my family doctor and made an appointment. He did some blood work and said he would get back to me. A few days later he called and asked me to stop around seven thirty that evening. He gave Evan and I the news that I was pregnant, that we were going to have a baby. He was a general practitioner and had not delivered a baby in awhile, and my situation was a little complicated so he sent me to a gynecologist. He called and the gynecologist said he could see me right away as he was just getting ready to leave the office. We went over and he examined me and validated

the pregnancy. I started crying and he asked me why. I told him that I was not supposed to be able to have a baby, and I was so happy. He told me that he was going to make arrangements for me to go see a doctor in Boston who was a surgeon because he was pretty sure that I would have to have the baby by cesarean section.

The doctor in Boston was really nice; he told me that this visit would be about two hours as he wanted to find out all about my background and also about me and my lifestyle. When we finished he was really interested in all that I told him. He suggested that I go to Mass General and ask Dr. Morton—the doctor I had in the hospital—for my x-rays so that he could take a look at my spinal fusions. After I did that I was to call his office and make another appointment, and we would talk about what the plans would be for having the baby.

Evan and I followed through with this, and I went to see Dr. Morton at Mass General, and he told me that he would not release the x-rays as no one except the doctors at Lakeville would understand them. Dr. Morton wanted to set up an appointment for me to have an abortion. I said absolutely not.

He said if I was to pursue having this baby I would die. The possibility of both the baby and I dying or just the baby was to be considered seriously.

Evan and I looked at each other in shock, and I said absolutely not. The doctor said we should go home and talk about it. I was exhausted and very scared. We drove home and when we got there I called my surgeon and set up an appointment for the following day. He certainly was an angel sent from above. He said forget the x-rays. We can figure things out without them. It was definitely decided on the cesarean section. He said he would use stainless steel wire and clamps to be sure that there would not be an infection. He said the cat gut sutures tended to cause infection at times. He put me on vitamins and said that I would go to see the doctor in Malden for my regular checkups. He suggested that I should quit work as this would give me the chance to get lots of rest. I did work for two more months as Evan had to go on another cruise, and I felt comfortable in the little apartment we were in, and the landlady was always downstairs. He was gone from mid-January to mid-April. We wrote each day. I really missed him. At the same time I was glad he was not with me for

the time I had the morning sickness. I quit work before it got real bad. I spent time going out with a school chum of mine who was also pregnant. We would accompany each other to doctor's visits and would share the ups and downs of pregnancy. Evan returned home in mid-April, and we started looking for an unfurnished apartment. He was discharged from the navy in May of 1955. We found an unfurnished apartment and purchased the bedroom and kitchen set plus the television from the landlady. She had built a home in New Hampshire and was moving; she offered the whole package for thirty dollars. Ginnie and Gordon offered to buy us a living room set and also to give us the crib they used for Marjie. We were all set and ready to go. I was very excited about my new place. I loved decorating and fixing it up. Evan was out of the navy and was working for a semiconductor company. He worked the 3 p.m. to 11p.m. shift and was home with me in the mornings.

My new landlords, who lived on the second floor (we were on the first), had two small children. I could hear the sounds upstairs so I wasn't afraid to be home alone while Evan worked. My time to go in and have the baby was

approaching; I spent time buying clothes and fixing up the room. Ginnie had a baby shower for me as did my friend Jane; she was to be the godmother of the baby.

On September 18, 1955 I was to be admitted to the Osteopathic Hospital in Jamaica Plain, Massachusetts. I stopped on my way at the Sacred Heart church to light a candle and ask God and the Blessed Mary to keep me and the baby safe and healthy. I had a friend who kept telling me the baby would be so small because she thought I didn't even look pregnant. I had only gained twelve pounds and I was tiny, but each time she said this I would flinch at the mention of it. It was so important for the baby to be healthy; I had done everything I was supposed to do and ate all the right foods and exercised.

On September 19, 1955, Alan Francis Perkins was born at 7:05 a.m. weighing in at 7 pounds and 1 ½ ounces. He was very healthy and so beautiful. He had the biggest blue eyes and light brown hair and the roundest face and very deep dimples in his cheeks. When they brought him in to me and laid him in my arms, my heart just filled with love for this perfect little baby of mine and Evan's, who in spite of all the doctors from my past that wanted me not to

have him, arrived being so perfect. It certainly was a miracle. The recovery was a little on the rough side. It was discovered that I was anemic, and it took eight blood transfusions to bring my blood up to the right level. I had a day or two that I was really discouraged, but all it took was for one of the nurses to bring in my baby and I would forget about the discouragement I had felt. When I was strong enough to get up out of bed, I discovered another miracle. I stood on the floor and in my bare feet without the shoe with the lift, I would lean towards my right. It took a few minutes for me to realize that this wasn't happening anymore. I was standing with both legs even. I kept shifting back and forth to see if it was really true. It was and I was able to buy regular shoes, not needing the lift anymore. If I didn't have my faith in God and the good doctors who were willing to help me fill my dream of having my own baby this would have never happened.

Two weeks after Alan was born we brought him home from the hospital. I asked the doctor if it would be possible for me to have another baby. I had my boy now I would love to have a girl. He laughed at me and said you sure are brave after going through such a tough time and

now you are asking about another one. His suggestion was for me to wait at least two years before having another one. I loved my new role as a mother; the baby was everything that I wanted. He was so much fun and filled my days with love and happiness.

In two years I was anxious to pursue having another baby. Evan felt the same way. On July 30, 1958 our daughter Cynthia Diane Perkins was born. Cindy, as she would be referred to, weighed in at six pounds and ten ounces. She was a healthy baby with black hair and brown eyes and the softest skin. When they brought her in to me I was excited about her hair as it looked as though it was very curly, but they had not really washed her head off and it gave the appearance of being curly. She snuggled into my arms, and I could not believe how wonderful God was to me. He gave me my boy and now my girl. I could not think of another thing I could ever want in this life at the moment. Ginnie and Gordon were living in Connecticut at the time and came to Boston to see me. I guess from what they told me that for the two hours they were there I just kept repeating that it was a girl. Gordon laughed and said, "Yes, Gale, it is a girl." I didn't have the trouble with being

anemic with Cindy as the doctor made sure that I had shots during the pregnancy to help with this. Cindy was not supposed to be born until the 13th of August, and because of her being ready sooner I did not sign papers to have my tubes removed as I had planned. I felt two babies were really my gifts from God and I didn't want to push it any further, but because of her early arrival the papers did not get signed.

I was very satisfied with my life with my two children. Evan continued to work in electronics. We had moved a few times as each apartment we would rent he would fix it up and the landlords would go up on the rent and would rent it out for a higher rent so we would look for a new place. Finally, one day we decided to look for a home, which we found in Georgetown, Massachusetts. Alan was seven and in the second grade; Cindy was four and not in school. We decided that now that we had our own home, it would be nice to have another baby, and on June 15, 1964 Paul Evan Perkins was brought into this world weighing in at six pounds six ounces and was also a very healthy baby. Paul had his dad's eyes and when they laid him in my arms, I looked at him and told his dad that this kid has been here

before. His eyes were wide open as he looked up at me; it was like he knew all about life.

My three children have been the best gifts in my life. Evan and I would talk about how happy we were that we didn't let the docors talk us out of having children. It was something that we both felt so strongly about. My faith and belief in God helped us to make the right decision; without these beliefs we would not have experienced the happiness that Alan, Cindy, and Paul brought to our lives.

GINNIE

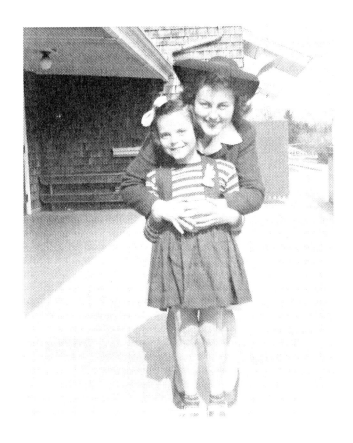

Ginnie was my mom's younger sister who took me in to live with her when I left the hospital. She was my guardian and the only mother figure that I knew. She had a lot of tragedy in her own life. She was only fourteen when she was admitted to North Reading Sanatorium and was there until she was twenty one. She had so many losses

when entering the hospital, and it was a big loss to her when they transferred me to another hospital. Her sisters and brother were all scattered in different places, and she had very few visitors because of it. Her brother and sister (who was my mom) both died while she was hospitalized.

When Ginnie was released from the hospital at age twenty one, she was to complete her four years of high school in one year. She then was hired to work at Harvard University in Boston. She lived at the Franklin Square house for women until she met and married Gordon. They then had a daughter Marjorie (named after my mom) and lived in Malden for the next ten years.

Ginnie was very sweet and loving and worked very hard to give me a life that was normal. She liked to look at the pictures of our family and tell about each one. I always felt sad when she did as she would just cry. She would say, "Galie," (a name she called me very lovingly at special times), "if you only knew what a bad person I am you would not want to live with me." Ginnie was the sweetest person I knew, and I could not imagine her being bad. She would sometimes be depressed and crying for several days after looking at the pictures.

Gordon's mother would suggest to her that she should put the pictures away. She grieved for her parents and her sister, my mother, and her brother Paul a lot and would sit for long periods of time and hug the pictures. It was hard for her to think of someone asking her to put them aside. Nana Reed would feel so sorry to see Ginnie so upset.

Ginnie and Gordon were very much in love. They met while Gordon was in the navy. They were married in Key West, Florida. Marjie, their daughter, was the love of their lives. One day Ginnie was not feeling too good and she just told me she had woman problems. She had to go in for some surgery, and when she came home she was not her normal self. She seemed to cry more and just sit and hug the album and the pictures of her family.

Gordon many times would refer to Ginnie as my mother, and she would say, "I am not your mother. I don't know why he says that. Your mother was kind and good and would never do what I have done." I was still trying to just imagine what she was talking about but it got to the point that we all just accepted the fact that in her mind she had done something that she thought was bad.

149

On my son Alan's first birthday, Marjie who was eleven and Gordon arrived for the party. I asked where Ginnie was. Gordon told me that he had to take her to St. Elizabeth's Hospital in Boston because she had locked herself in the house for days and would beg him not to go to work. I mentioned to Gordon that I had called her several times and she just kept repeating everything I said. Gordon looked very sad. He explained that when he arrived at the hospital with Ginnie she kept repeating continuously, "I have a monkey on my back." The doctors decided that she needed to have electric shock therapy; they were unable to find out why she was so upset. They felt the only way to treat her illness was with this type of therapy. She spent four weeks in the hospital, and when she came home she seemed to be better but still mentioned the monkey from time to time.

Ginnie had a fear of children wearing high-heeled shoes and she made sure that Marjie never wore hers. Ginnie had been with me when I fell down and hurt my back wearing her high heels. We decided that maybe she felt responsible for my fall. No one really could get her to say much more about it. I would say, "Ginnie, don't feel

bad about it. I am fine. Look, I am married, have three children, a nice home, and husband. That was a long time ago; I am healthy and just fine today." It was as though she never heard me saying it. It really hurt me to see her so broken up about this fall that happened so long ago. I felt I survived it. I am fine and very happy with my life. I would tell her, "I just need you to be well so my children can have a grandmother to love and have fun with and do special things with."

Just when it seemed that she was getting better she would have another bad spell. I arrived one day and she was sitting with a picture of me before the fall. I was two years old. She started talking about how I had to spend all those years in the hospital and go through all the suffering and pain, and then wear that awful shoe for so long and about the mean kids that would make fun of me. It reached a point where I didn't want to go visit her. The only time I would see her really happy would be on St. Patrick's Day; she loved her Irish heritage and the songs. I recall how all of my children were rocked to sleep by her singing the Irish lullaby to them.

Ginnie thought that if they moved somewhere different where no one knew her she would get better. She was embarrassed for her neighbors and people to know that she had a mental illness. Gordon left his job with the Boston and Maine Railroad where he was on the police force, and they moved to Connecticut. Marjie was only twelve years old. I felt sad about them leaving. I would really miss all of them. Ginnie had to go back to the hospital many times. She became very suspicious of people and because of this they were to move several times in the first couple of years. Finally, Gordon decided to buy a home. She seemed more contented than living in apartments.

She appeared to have settled in for the next few years. Marjie graduated high school and went on to nursing school. She also was to marry and have children of her own. This made Ginnie happy as she loved being a Grandma. She also liked taking care of the little ones.

At Christmas of 1963, Gordon, Marjie and Ginnie came to spend the day with my family. Ginnie said she had something to tell me. I said, "I have something to tell you." It was decided that I would go first. I told her I was

expecting another baby. She asked if the doctor thought I would be okay, and I told her yes. She said, "Galie, I think you have enough with the two children you have. You keep a nice house and you're a great Mom; I'm afraid another baby will be too much for you." I told her not to worry. I would be just fine.

"Now tell me your news," I said. Ginnie had the gift of writing poetry like her sister Marjie (my mom). She pulled out a paper and read me a poem titled, *My Maker has Given Me a Cross to Bear*. The poem was about her having bone cancer. Ginnie wrote about the pain in her life in the form of poetry. We both cried and held each other tight. She said, "You know, Galie, I might not see your new baby." I said I knew that she would. "You have to rock and sing the Irish Lullaby to this baby like you have done to the other two," I said. (Ginnie did live to rock and sing to my son Paul.)

Gordon had sold the house, and they moved to a house for the handicapped as Ginnie was now in a wheelchair. The house was in Feeding Hills, Massachusetts near to where Marjie was living. Evan and I would make the two hour trip at least twice a month to visit with Ginnie.

She was in very good spirits and we would have lots of fun. When her cancer became more advanced, we started to visit weekly. I felt a real gratitude towards this person who took me in and gave me some family life when I came out of the hospital.

We had just had a wonderful visit with Ginnie. We just sat and held hands for a long time. I sang her the Irish Lullaby she sang to my children when they were little. She was getting weaker each time we visited. Gordon had the hospice coming in a few times a week to help him out with her. On the ride home from visiting Ginnie, I looked over at the side of the road; a bright light had caught my eye, and down in a hollow in the road was this grotto with the Blessed Mother inside. It was really beautiful. I looked at it and then I heard this voice telling me, "You were not wearing her high heels when you fell down the stairs. In fact, you didn't fall. You were shoved by Ginnie who was so jealous of you. You came into her home and became the focus of her parents' lives. Then, their adopting you as their own was more than she could handle; she was only twelve. They left her to take care of you a lot, and one day she just shoved you down the stairs. This is what she has had to live

with all of these years." I started crying really hard. Evan pulled over and asked, "Gale, what is wrong?" I told him what I had heard. He held me for awhile and asked what I was feeling. I said, "So much compassion for Ginnie; she has suffered all these years. She took me to live with her and had to see what she did every day. My God, Evan it is no wonder she has been so emotionally sick all these years." The ride home was a very quiet one; I know Evan as well as myself was trying to absorb what had happened.

I looked at the grotto on the side of the road, which was at least fifty feet away, and thanked the Blessed Mother for revealing that to me. Evan really felt bad; but he also felt angry. I told him she was just a little girl and I can understand it. She sure has paid her dues as far as I am concerned. Look at me, I am healthy and walking and have had children and grandchildren. What does she have but a lot of guilt and pain? My heart just ached for her. How she must have suffered. Now she is fighting this battle with cancer; I just asked God to please give her some peace in her last days.

We went back two weeks later as Marjie called and said her mom was really failing. She loved to have me fix

her hair; she also loved black satin underwear and nightgowns. I looked for black satin sheets for her but could only find dark brown ones. I showed her the sheets and she smiled and said, "Galie, you are the best." Marjie and I then gave her a complete bed bath; I washed her hair with the dry shampoo and cut and curled it for her. Marjie and I put the sheets on Ginnie's bed. She kept showing me how she was able to move her toes. I said, "Wonderful," but they were not moving. When we had her all cleaned up and looking gorgeous in her new black satin nightgown; we asked her if there was anything special she would like us to do for her. She laughed and said she wanted us to put Gordon in the lift that he put her in to get her out of bed. Let's see how he likes it. He was a good sport and let Marjie and I do that. We didn't leave him there too long. After we finished with all her wishes and needs, she asked that everyone but Evan and I leave the room. She needed to talk to me, but wanted Evan to be with me. She started off by calling me Galie, which immediately told me something was important to her. She said I want you to know that I love you very much and what I have to tell you is not easy, but it has to be told and I am the only one who can tell you

as I am the only one who knows. I don't have long on this earth. My time is about done.

She then told Evan and me the same story I had heard driving down the road and looking at the grotto just the week before. We both cried. I told her she was a child and acted as any hurting child would. I am fine and most importantly, "I forgive you, Ginnie; I love you so much. You have given me a family life that I never expected and lots of love." I begged her to please forgive herself. I told her how much I loved her and how grateful I was that she took me in to live with her, but most of all how sorry I was that she carried what she called a monkey on her back all those years. She said, "I will never talk again. I don't deserve to."

Ginnie died a week later in October of 1981. I didn't get back to see her. I talked to her on the phone at the hospital. Marjie called and said she had little time left and she asked her if she would like to talk to me; she said Ginnie shook her head yes. Marjie and Gordon were excited as they figured she would at least speak. She didn't talk but I did. I told her told her how much I loved her and that I forgave her with all my heart and was sorry for her

pain. I told her God forgave her also. I said goodbye to her; she didn't respond. Marjie said she shook her head and smiled.

Gordon and Marjie said she never spoke to them at all after my visit. I was not sure that I wanted to tell them the story. I knew if I should tell them I would feel it in my heart when it was the right time.

We went back for a week to help Gordon clean out Ginnie's things. He mentioned so many times about her not talking. Evan looked at me and nodded. I knew I should tell them. I did. It relieved a lot of their anxiety. Gordon felt bad, but he said he was very proud of me and the way I handled it. He felt heartsick that she couldn't have told us many years before so we could have helped her. I told him I was sure we helped her just by loving her and being a family.

I know I helped the only way I knew how, with love, respect, and most of all with forgiveness.

MY LIFE CONTINUES

I decided before I started my story that I would like to go back to Lakeville where I spent my childhood. It took me almost six months of making phone calls to get permission to do this. The hospital had been closed since 1991 due to the decline in tuberculosis. The original building that I was in had been condemned, making it very difficult to be allowed the visit. I had to promise that I would not attempt to go inside and that I would keep the visit down to a minimum of two hours. The date given to me two weeks previous was September 12, 2001, the day after the bombing of the twin towers. My friend and I had booked a hotel in nearby Plymouth for a week. I wanted to take my time and visit the town of Lakeville and become familiar with the road to the hospital. There was a security trailer at the end of the premises; I was able to go in and talk to the guard a few days before I was to make the visit. He assured me that he had my name plus the permission document for me to sign when I arrived to make the visit. I was a little bit nervous about the happenings the day before

in New York; I thought perhaps they might renege on the permit, but fortunately they did not.

It was hard to get my bearings at first as the hospital was completely overgrown with vines and shrubs. I was hoping to get a peek inside, but the windows and doors were all boarded up. I was to stand in some of the same areas that I stood in as a little girl; it had been fifty three years since I had left this childhood place. I felt very humble and peaceful as I looked back in time, and then wandered ahead to where I am at this time in my life; so many twists and turns in the road; so many wonderful blessings along the way. I reflected back on my friend Angie and could hear her voice and see her brown eyes and her smile. A bit of sadness touched my heart, followed by the joy of knowing this angel.

I excitedly walked around and told my friend as much as I could remember of the things that happened. I found myself in awe of the condition of the place. There were some changes such as brick on the porch instead of the cement, and other changes too numerous to mention. I was fortunate that we were not only able to take photographs, but we did some videotaping. I searched for the chimney

stack that I had seen the lady in the smoke come from; it had been taken down, the guard thought, when they put up the new building. I tried to find the window that was by my bed, but it was all overgrown with flowering shrubs and vines; I think I found it but was not sure. It took me the rest of the day to really absorb all that I had seen and felt that day. I am glad I had the opportunity to go back and walk through the grounds and spend the time. I heard shortly afterwards from friends who live in the area that the hospital property of seventy plus acres was sold in the next year or so.

Evan had died five years before; and I was now ready to sit and seriously fulfill the dream he had for me: to write my story. Many people have touched my heart and given me support throughout the years, way too many to mention; I thank each and every one of them. I keep them in the fabric of my heart that I like to look at as a quilt with each square representing all of these special friends and family. When the road in my life has become rough for me, I only have look into my heart and recall each and every person who is a part of this fabric; a feeling of peace and love comes over me just like a warm quilt.

I was able to fulfill a few dreams of my own during the years. One was to work in the fields that the Mass Rehab person told me I could not. I found it necessary to go to work to help Evan with the household finances. The first job I worked at for three years was in a nursing home as a nurse's aid. I was able to do this without any problems to my health at all. One day the occupational therapist in the nursing home mentioned how good I was with the patients and asked me if I would be interested in working at Baldpate Hospital in Georgetown in the craft area. She said they needed someone on the weekends and holidays to run the area. This would be a great opportunity for me as it was right in the town where I lived, and it was only part time so I would be able to be home with my children more. This was so important to me. I didn't want to miss a moment of their growing up if I didn't have to. I didn't really like being away from my children as much as I was when working full time.

I applied for the job and was hired. It was just the work I had always wanted to do: help people with learning how to make something that helped them feel good about themselves. I had worked about a year when I started to

feel very tired. I seemed to have lost my appetite and was losing weight. I went to the doctor's, and after some tests, it was discovered that I had vaginal cancer. It seemed like the end of the world to me; it was recommended that I go in to have a hysterectomy immediately. I remember writing letters to my husband and children and taking them in the suitcase I packed for the hospital. I was really scared and did not know if I would make it through this surgery. I tried to keep focused on my family and my home and a job that I really loved. I was very glad to wake up after the surgery and know I was still alive. The prognosis was good. I would have to go for some treatments for awhile but everything looked good.

I was unable to go back to work for a couple of months. The director of the program at the time filled my weekend job with someone else. I needed to continue working. I heard from a friend about a job working as a switchboard operator in her friend's home. I applied and worked there for about two years. One day I received a call from a friend who was a chef at the hospital; he told me that the director had left to take another job. He said he told the owner about me, and she wanted me to call her and set up

an appointment. I was afraid at first because this was a full time, and I would have to write notes and go to meetings, something I didn't have to do on weekends. Well, like everything else I did in life, I took a chance and went for the interview and was hired. I remember driving out of the parking lot and thinking, "What have I done?" I started working full time in 1975 and retired in 1997. It was a job that I found a lot of fulfillment in. Working there was like having an extended family.

I had another family that I am most grateful to and that is my Clown family. I never thought much of becoming a clown. I recall the nurses many years ago and my friend Phyllis telling me I was a clown. Now it was to become a reality. I worked with an expressive therapist at the hospital who had gone to a clown convention and met a lot of clowns; she told me that she and the professional clowns were going to put a series of clown classes together at a local community college. I was excited to be asked and could not wait to go.

This is when Hugs & Kisses the Clown was born. It was in the seventies and I continue to clown to this day. Later in years I talked Evan into becoming a clown. At first

he was reluctant. He said he didn't know what to say. Our godchild, Annie, had told her teacher that I was a clown and that I was coming to visit in November for Thanksgiving. I told Evan I didn't want to do this alone; it was the first time I had worked at a school and I needed a partner. I didn't push too much. I just waited for him to say yes. We had six weeks before we were leaving for Texas. One night I woke up and went to the kitchen table with a pen and paper and started to write a program for Evan and me to do. I remembered Annie telling us that the teacher told the class that clowning was a form of communicating; Evan didn't want to talk, and the program I wrote was for Perko the Silent Clown. He would hold a magic flower in his hand and then make it wilt if he wanted to talk to me. When the day came for the show, the children loved it as they would have to tell me that Perko wanted to talk to me. The show was a big success as was Perko, and needless to say he became a clown that day. He later took on the character and the name of Hayseed that was given to him by his daughter. Hayseed, Hugs & Kisses and their grandchildren Danielle (Sparkles the clown) and Jeff (Sneakers the clown) went on to do many birthday parties and functions together. I

remember one day as we came back from doing a gig, my daughter had some friends visiting, and we all walked in and she introduced us as her family, the clowns. It was probably the best laugh we got that day.

When Evan died, the head of the clown family, Hap, asked what he could do for me. I thought for a moment and reflected on what would Evan like. My answer was firm and clear. I asked if the clowns would come in their clown costumes to the wake. There were thirty some clowns at Evan's wake. The funeral director took me aside and told me that he was friends with the Chaplain of the Ringling Brothers' Circus. He said if I can get ahold of him and he isn't busy, would you like to have him do the eulogy for Hayseed the clown. My eyes filled with tears and I said yes. This Chaplain did such a wonderful job of telling about the heart of a clown that there was hardly a dry eye in the church. I just silently thanked God. My grandson Jeff took over his grampa's clown character and has done it proud. He is Hayseed #2. Hayseed two and Hugs & Kisses have done many birthday parties, fundraisers, and family parties together. We make a great team!

My spiritual family has and will always be with me. I would have been so lonely all those years had I not met God and the Blessed Mother. I was thankful then, and I continue to be thankful for the gift of spirituality.

As I look at the little girl with the big brown eyes and the large bow in her hair looking at her aunty Eunice, and telling her that some day "I will run and run" and when I read the poem written by my Mom, *The Baby's Cross*, I have to say that my heart wells up with pride for all I have done and all I will continue to do in my journey on this earth.

HUGS TO ALL WHO READ THIS BOOK!